What is Post-Modernism?

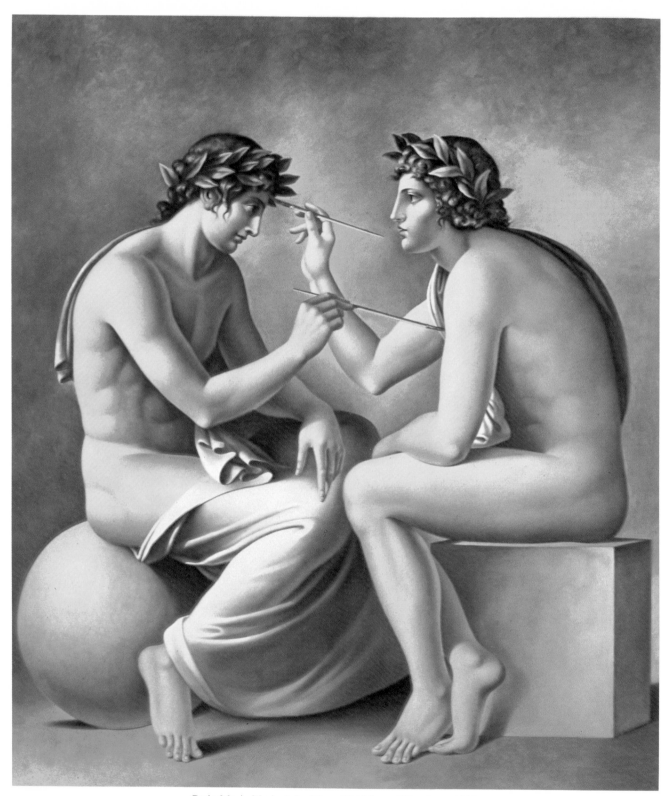

Carlo Maria Mariani, La Mano Ubbidisce all'Inteletto, 1983.

CHARLES JENCKS

What is Post-Modernism?

ACADEMY EDITIONS LONDON / ST. MARTIN'S PRESS NEW YORK

EDITORIAL NOTE

'What is Post-Modernism?' was first given as a paper at a conference on Post-Modernism at Northwestern University, Evanston, Illinois in October, 1985, and again later that month in Hannover, Germany, at a second conference on the same subject organised by Dr Peter Koslowski for *Civitas*. It was serialised in *Art & Design* magazine and published in volume form in 1986 with additional illustrations. This third edition includes additional sections together with further illustrations.

Back cover: Michael Graves, Humana Building, Louisville, Kentucky, 1982-5, South façade. (Photo Paschall/Taylor) *Page 1*: Michael Graves, *Portlandia*, study for Portland Building sculpture, 1980. *Frontispiece*: Carlo Maria Mariani, *La Mano Ubbidisce all'Inteletto*, 1983, oil on canvas, 78$\frac{1}{2}$ x 69in. For Modernists the subject of art was often the process of art; for Post-Modernists it is often the history of art. Mariani adapts eighteenth-century conventions, including even the 'erotic frigidaire', to portray his allegory of autogenous creation: art painting itself. *The Hand Submits to the Intellect* recalls the Greek myth of the origins of painting and suggests that art today is still self-generated and as hermetically sealed as his ideal, claustrophobic space. (Courtesy of Sperone Westwater Gallery, New York)

Published in Great Britain in 1986 by
ACADEMY EDITIONS
an imprint of the Academy Group Ltd, 7 Holland Street, London W8 4NA

Third revised enlarged edition 1989

ISBN 1-85490-009-9

Published in the United States of America by
St. Martin's Press, 175 Fifth Avenue, New York, NY 10010
Library of Congress Catalog Card Number 86-042838

ISBN 0-312-03988-3

Printed and bound in Hong Kong

Contents

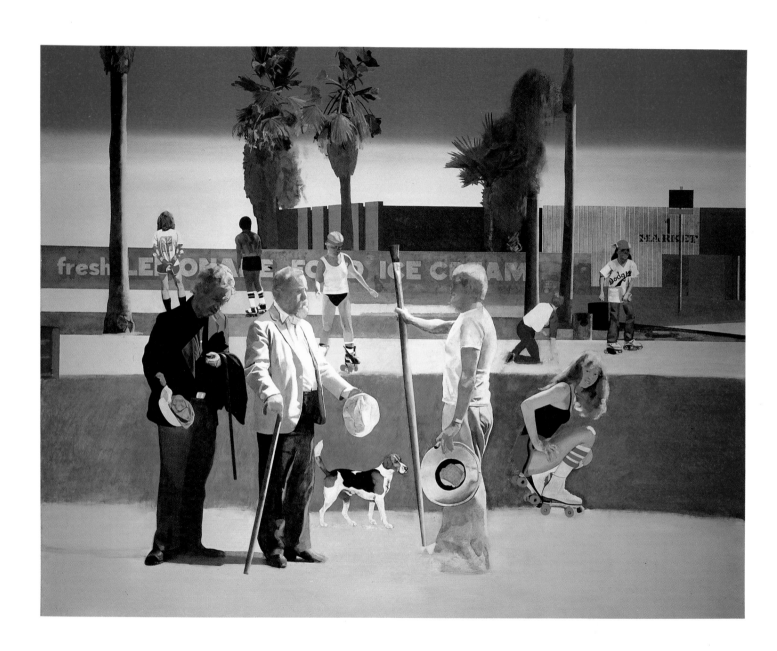

Foreword

The Modern Age, which sounds as if it would last forever, is fast becoming a thing of the past. Industrialisation is quickly giving way to Post-Industrialisation, factory labour to home and office work and, in the arts, the Tradition of the New is leading to the combination of many traditions. Even those who still call themselves Modern artists and architects are looking backwards and sideways to decide which styles and values they will continue.

The Post-Modern Age is a time of incessant choosing. It's an era when no orthodoxy can be adopted without self-consciousness and irony, because all traditions seem to have some validity. This is partly a consequence of what is called the information explosion, the advent of organised knowledge, world communication and cybernetics. It is not only the rich who become collectors, eclectic travellers in time with a superabundance of choice, but almost every urban dweller. Pluralism, the 'ism' of our time, is both the great problem and the great opportunity: where Everyman becomes a Cosmopolite and Everywoman a Liberated Individual, confusion and anxiety become ruling states of mind and ersatz a common form of mass-culture. This is the price we pay for a Post-Modern Age, as heavy in its way as the monotony, dogmatism and poverty of the Modern epoch. But, in spite of many attempts in Iran and elsewhere, it is impossible to return to a previous culture and industrial form, impose a fundamentalist religion or even a Modernist orthodoxy. Once a world communication system and form of cybernetic production have emerged they create their own necessities and they are, barring a nuclear war, irreversible.

The challenge for a Post-Modern Hamlet, confronted by an *embarras de richesses*, is to choose and combine traditions selectively, to *eclect* (as the verb of eclecticism would have it) those aspects from the past and present which appear most relevant for the job at hand. The resultant creation, if successful, will be a striking synthesis of traditions; if unsuccessful, a smorgasbord. Between inventive combination and confused parody the Post-Modernist sails, often getting lost and coming to grief, but occasionally realising the great promise of a plural culture with its many freedoms. Post-Modernism is fundamentally the eclectic mixture of any tradition with that of the immediate past: it is both the continuation of Modernism and its transcendence. Its best works are characteristically doubly-coded and ironic, making a feature of the wide choice, conflict and discontinuity of traditions, because this heterogeneity most clearly captures our pluralism. Its hybrid style is opposed to the minimalism of Late-Modern ideology and all revivals which are based on an exclusive dogma or taste.

This, at least, is what I take Post-Modernism to be as a cultural movement and historical epoch. But, as the reader will discover, the word

[1] Peter Blake, *'The Meeting'* or *'Have a Nice Day, Mr Hockney'*, 1981-3, oil on canvas, 39 x 49in (detail on front cover). An ironic meeting of 1960s 'Pop' painters at the Post-Modern academy in the 1980s. This new version of Courbet's *The Meeting or Bonjour Monsieur Courbet* is both a contemporary comment on Classicism and a classical composition in itself. The meeting is between three representational artists – Howard Hodgkin, Peter Blake and David Hockney – the last with a brush rather than a staff in his hand. The squatting girl's pose is taken partly from a skating magazine and partly from classical sculpture. The heroic meeting in 'Venice', California, commemorates a historical act, if not a grand public one, as the nineteenth-century Classicist would no doubt have preferred. Monumentality and banality, a timeless present and the transient afternoon are set in serene contrast. (Courtesy of the Tate Gallery, London)

and concept have changed over fifty years and have only reached such a clarification in the last ten. Seen as progressive in some quarters, it is damned as reactionary and nostalgic in others; supported for its social and technological realism, it is also accused of escapism. Even, at times, when it is being condemned for its schizophrenia this 'failing' is turned by its defenders into a virtue. Some writers define it negatively, concentrating on aspects of inflation, the runaway growth typified by a multiplying economy.[1] But a critical reading of the evidence will show that fast-track production and consumption beset all areas of contemporary life and are not the monopoly of any movement.

The concept of Post-Modernism was apparently first used by the Spanish writer Federico De Onis in his *Antología de la poesía española e hispanoamericana*, 1934, to describe a reaction from within Modernism, and then by Arnold Toynbee in his *A Study of History* written in 1938, but published after the war in 1947. For Toynbee the term was an encompassing category describing the new historical cycle which started in 1875 with the end of Western dominance, the decline of individualism, capitalism and Christianity, and the rise to power of Non-Western cultures. In addition it referred to a pluralism and world culture, meanings which are still essential to its definition today, and positively so. But Toynbee was, on the whole, sceptical of the 'world village' – as McLuhan was later to term it – and it is interesting that this scepticism was shared by those writers who first used the term polemically, the literary critics Irving Howe and Harold Levine, for this essentially negative description has stayed with the movement, becoming in the event both a scourge and a challenge, an insult and a slogan to be carried into battle.[2] Their usage, in 1963 and 1966, was – as E.H. Gombrich has shown of the first use of the terms Gothic, Mannerism, Baroque, Rococo and Romanesque – malevolent enough to sting, catch on and then become positive.[3] Labels, like the movements they describe, often have this paradoxical power: to issue fruitfully from the mouths of detractors. No wonder their growth can resemble a twisting, organic shape, not only a tree or a river but, in the case of Post-Modernism, a snake.

Virtually the first positive use of the prefix 'post' was by the writer Leslie Fiedler in 1965 when he repeated it like an incantation and tied it to current radical trends which made up the counter-culture: 'post-humanist, post-male, post-white, post-heroic . . . post-Jewish'.[4] These anarchic and creative departures from orthodoxy, these attacks on Modernist elitism, academicism and puritanical repression, do indeed represent the first stirrings of Post-Modern culture as Andreas Huyssen later pointed out in 1984, although Fiedler and others in the 1960s were never to put this argument as such and conceptualise the tradition.[5] This had to wait until the 1970s and the writings of Ihab Hassan, by which time the radical movements which Fiedler celebrated were, ironically, out of fashion, reactionary, or dead.

Ihab Hassan became by the mid 1970s the self-proclaimed spokesman for the Postmodern (the term is conventionally elided in literary criticism) and he tied this label to the ideas of experimentalism in the arts and ultra-

1 See Charles Newman, *The Post-Modern Aura: The Act of Fiction in an Age of Inflation,* with a preface by Gerald Graff, Northwestern University Press, Evanston, Illinois 1985.

2 See Irving Howe, 'Mass Society and Postmodern Fiction' (1963) in *The Decline of the New,* Harcourt Brace and World, New York 1970. *The Decline of the New,* as the title suggests, also treats the subject. See also Gerald Graff, 'The Myth of the Postmodern Breakthrough' reprinted in *Literature Against Itself,* The University of Chicago Press, Chicago and London 1979. Graff's critique of the Post-Modern seems to be more aptly directed at Late-Modern literature, as I mentioned to him when we met at a conference in Evanston, 1985, but he is using the term as defined by Howe, Levin, Charles Olsen, Hassan and others. For Harold Levin see 'What was Modernism?', *Refractions: Essays in Comparative Literature,* Oxford University Press, New York 1966.

3 For this idea and a discussion of several terms see E.H. Gombrich, 'The Origins of Stylistic Terminology', *Norm and Form,* Phaidon, London 1966, pp. 83-6, and 'Mannerism: The Historiographic Background', also printed in *Norm and Form,* pp. 99-106.

4 See Leslie Fiedler, 'The New Mutants' (1965) published in *The Collected Essays of Leslie Fiedler Vol. II,* Stein and Day, New York 1970, and *A Fiedler Reader,* Stein and Day, New York 1977, pp. 189-210.

5 See Andreas Huyssen, 'Mapping the Postmodern', *New German Critique,* No. 33, Fall 1984, devoted to *Modernity and Postmodernity,* University of Wisconsin-Milwaukee, 1984.

technology in architecture – William Burroughs and Buckminster Fuller, 'Anarchy, Exhaustion/Silence . . . Decreation/Deconstruction/Antithesis . . . Intertext . . .' – in short those trends which I, with others, would later characterise as Late-Modern. In literature and then in philosophy, because of the writings of Jean-François Lyotard (1979) and a tendency to elide Deconstruction with the Post-Modern, the term has often kept its associations with what Hassan calls 'discontinuity, indeterminancy, immanence'.[6] Mark C.Taylor's curiously titled *ERRING, A Postmodern A/Theology* is characteristic of this genre which springs from Derrida and Deconstruction.[7] There is also a tendency among philosophers to discuss all Post-Positivist thinkers together as Post-Modern whether or not they have anything more in common than a rejection of Modern Logical Positivism. Thus there are two quite different meanings to the term and a general confusion which is not confined to the public. This and the pretext of several recent conferences on the subject has led to this little tract: 'What is Post-Modernism?' It *is* a question, as well as the answer I will give, and one must see that its continual growth and movement mean that no definitive answer is possible – at least not until it stops moving.

In its infancy in the 1960s Post-Modern culture was radical and critical, a minority position established, for instance, by Pop artists and theorists against the reduced view of Modern art, the aestheticism reigning in such institutes as the Museum of Modern Art. In architecture, Team Ten, Jane Jacobs, Robert Venturi and the Advocacy Planners attacked 'orthodox Modern architecture' for its elitism, urban destruction, bureaucracy and simplified language. By the 1970s, as these traditions grew in strength and changed and Post-Modernism was now coined as a term for a variety of trends, the movement became more conservative, rational and academic. Many protagonists of the 1960s, such as Andy Warhol, lost their critical function altogether as they were assimilated into the art market or commercial practice. In the 1980s the situation changed again. Post-Modernism was finally accepted by the professions, academies and society at large. It became as much part of the establishment as its parent, Modernism, and rival brother, Late-Modernism, and in literary criticism it shifted closer in meaning to the architectural and art traditions.

John Barth (1980), and Umberto Eco (1983), among many other authors, now define it as a writing which may use traditional forms in ironic or displaced ways to treat perennial themes.[8] It acknowledges the validity of Modernism – the change in the world view brought on by Nietzsche, Einstein, Freud *et. al.* – but, as John Barth says, it hopes to go beyond the limited means and audience which characterise Modernist fiction: 'My ideal postmodernist author neither merely repudiates nor merely imitates either his twentieth-century Modernist parents or his nineteenth-century premodernist grandparents. He has the first half of our century under his belt, but not on his back. Without lapsing into moral or artistic simplism, shoddy craftsmanship, Madison Avenue venality, or either false or real naiveté, he nevertheless aspires to a fiction more democratic in its appeal

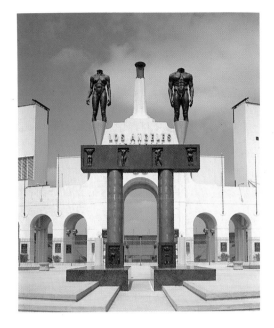

[2] Robert Graham, *Olympic Arch*, Los Angeles, 1984, bronze, metal and granite, c.20 x 12 x 4ft. The search for a wider audience has led some sculptors towards urban commissions which comment on place and activity – a form of context-specific art. Here Olympic athletes, truncated to signify physical power, go through their exercises which are also those of the sculptor. The emphasis on 'perfect casting' and 'absolute realism' recalls classical norms while the disjunctions and combined materials make it unmistakably of the present. (Courtesy of the artist)

6 See Ihab Hassan, 'The Question of Postmodernism', *Romanticism, Modernism, Postmodernism*, Harry R. Garvin (ed.), Bucknell University Press, Lewisberg, Toronto and London 1980, pp. 117-26.

7 See Mark C. Taylor, *ERRING, A Postmodern A/Theology*, The University of Chicago Press, Chicago and London 1984.

8 See John Barth, 'The Literature of Replenishment, Postmodernist Fiction', *The Atlantic*, January 1980, pp. 65-71, and Umberto Eco, 'Postmodernism, Irony, the Enjoyable', *Postscript to the Name of the Rose*, Harcourt Brace Jovanovich, New York and London 1984, first published in Italian, 1983. Umberto Eco's *The Name of the Rose* became, of course, a best-selling version of the kind of Post-Modern fiction that Barth and Eco describe in their theoretical writing.

[3] Stephen Mckenna, *Clio Observing the Fifth Style*, 1985, oil on canvas, 78 x 110 in. Mckenna looks to T.S. Eliot and Giorgio de Chirico, among traditionalist Moderns, for their ironic and melancholic appropriations of historical fragments. (Courtesy of Edward Totah Gallery, London)

[4] Giorgio de Chirico, *La Lettura*, 1926, oil on canvas, 36 x 28in. Early and Late De Chirico works have inspired a generation of Post-Modern architects such as Aldo Rossi and Leon Krier and artists such as Gerard Garouste and Stephen McKenna. The appeal of his enigmatic allegories lies perhaps in their portrayal of a lost, classical world; a dignified image of man, nature and architecture set in quixotic disruption. Many other Modern artists – Picasso, Moore, Balthus, Morandi, Magritte – have had an equal influence on Post-Modernists and thus one can speak of an evolution from, as well as a contrast between, the two periods. (Courtesy of Robert Miller Gallery, New York)

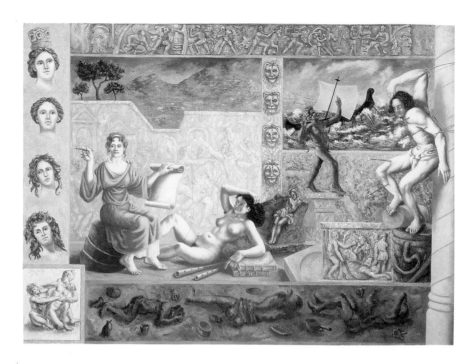

than such late-modernist marvels (by my definition and in my judgement) as Beckett's *Stories and Texts for Nothing* or Nabokov's *Pale Fire*. He may not hope to reach and move the devotees of James Michener and Irving Wallace – not to mention the lobotomized mass-media illiterates. But he *should* hope to reach and delight, at least part of the time, beyond the circle of what Mann used to call the Early Christians: professional devotees of high art.'[9] This search for a wider audience than the Early Christians also distinguishes Post-Modern architects and artists from their Late-Modern counterparts and from the more hermetic concerns that Ihab Hassan defined in the 1970s. There are of course many other specific goals on the agenda which give Post-Modernism a direction.

But because its meaning and tradition change, one must not only define the concept but give its dates and specific context. To reiterate, I term Post-Modernism that paradoxical dualism, or double coding, which its hybrid name entails: the continuation of Modernism and its transcendence. Hassan's 'postmodern' is, according to this logic, mostly Late-Modern, the continuation of Modernism in its ultra or exaggerated form. Some writers and critics, such as Barth and Eco, would agree with this definition, while just as many, including Hassan and Lyotard, would disagree. In this agreement and disagreement, understanding and dispute, there is the same snake-like dialectic which the movement has always shown and one suspects that there will be several more surprising twists of the coil before it is finished. Of one thing we can be sure: the announcement of death is, until the other Modernisms disappear, premature.

9 John Barth, *op. cit.*, p. 70.

* * *

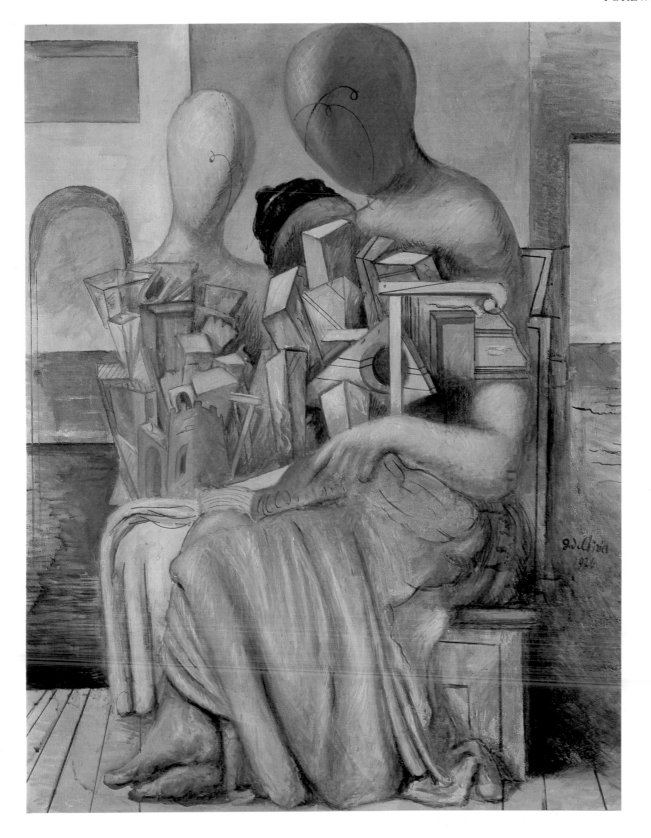

I The Protestant Inquisition

In October 1981 *Le Monde* announced to its morning readers, under the section of its newspaper ominously headed 'Décadence', that a spectre was haunting Europe, the spectre of Post-Modernism.[10] What Frenchmen made of this warning as they bit into their croissants is anybody's guess, especially as it came with the familiar Marxist image of a ghost looming over their civilisation (and their coffee) – but they probably soon forgot the phantom and looked forward to next morning's 'Décadence' column, for in our culture one ghost grows boring and must be quickly replaced by the next. The problem, however, has been that critics – especially hostile, Modernist critics – won't let this one dissolve. They keep attacking the phantom with ever-increasing hysteria, making it grow into quite a substantial force that upsets not only *le petit déjeuner* but also international conferences and price quotations on the international art market. If they aren't careful, there will be a panic and crash at the Museum of Modern Art as certain reputations dissolve like dead stock.

Clement Greenberg, long acknowledged as the theorist of American Modernism, defined Post-Modernism in 1979 as the antithesis of all he loved: that is, as the lowering of aesthetic standards caused by 'the democratization of culture under industrialism.'[11] Like our 'Décadence' columnist he saw the danger as a lack of hierarchy in artistic judgement, although he didn't go so far as the Frenchman in calling it simply 'nihilism'. Another art critic, Walter Darby Bannard, writing in the same prestigious *Arts Magazine* five years later, continued Greenberg's crusade against the heathens and re-stated the same (non) definition, except with more brutal elaboration: 'Postmodernism is aimless, anarchic, amorphous, self-indulgent, inclusive, horizontally structured, and aims for the popular.'[12] Why did he leave out 'ruthless kitsch' or the standard comparison with Nazi populism that the architectural critic Ken Frampton always adds to the list of horrors? Ever since Clement Greenberg made his famous opposition between 'Avant-Garde and Kitsch' in a 1939 article, certain puritanical intellectuals have been arguing that it has to be one thing or the other, and it's clear where they classify Post-Modernism, although of course if it's really 'horizontally structured' and 'democratic' it can't be at the same time Neo-Nazi and authoritarian. But consistency has

10 Gérard-Georges Lemaire, 'Le Spectre du post-modernisme', 'Décadence', *Le Monde Dimanche*, 18 October 1981, p. XIV.

11 Clement Greenberg, 'Modern and Post-Modern' – presented at the fourth Sir William Dobell Memorial Lecture in Sydney, Australia, on 31 October 1979 and published the following year in *Arts Magazine*.

12 Walter Darby Bannard, 'On Postmodernism', an essay originally presented at a panel on Post-Modernism at the Modern Languages Association's annual meeting in New York, 28 December 1983, published later in *Arts Magazine*.

never been a virtue of those out to malign a movement.

Quite recently the Royal Institute of British Architects (RIBA) has been hosting a series of revivalist meetings which are noteworthy for their vicious attacks on Post-Modernism. In 1981 the Dutch architect Aldo van Eyck delivered the Annual Discourse titled 'Rats, Posts and Other Pests', and one can guess from this appellation how hard he attempted to be fair-minded. He advised his cheering audience of Modernists in a capital-lettered harangue, 'Ladies and Gentlemen, I beg you, HOUND THEM DOWN AND LET THE FOXES GO' – tactics not unlike the Nazi ones he was deploring, although the hounds and foxes give this pogrom an Oscar Wilde twist.[13] If Van Eyck advised letting the dogs loose on Post-Modernists, the older Modern architect Berthold Lubetkin limited himself, on receiving his Gold Medal at the RIBA, to classing them with homosexuals, Hitler and Stalin: 'This is a transvestite architecture, Heppelwhite and Chippendale in drag.'[14] And he continued to compare Post-Modernism with Nazi kitsch in subsequent revivalist *soirées* in Paris and at the RIBA, even equating Prince Charles with Stalin for his attack on Modernism.[15] One could quote similar abuse from old-hat Modernists in America, Germany, Italy, France, indeed most of the world. For instance the noted Italian critic Bruno Zevi sees Post-Modernism as a 'pastiche . . . trying to copy Classicism' and 'repressive' like fascism.[16]

We can see in all these howls of protest something like a negative definition emerging, a paranoic definition made by Modernists in retreat trying to hold the High Church together, issuing daily edicts denouncing heresy, keeping the faith among ever-dwindling numbers. It is true they still control most of the academies, sit on most of the aesthetic review boards, and repress as many Post-Modern artists and architects as they can, but the mass of young professionals have fled from the old Protestant orthodoxy and are themselves bored and fed up with the taboos and suppressions. In any international competition now more than half the entries will be Post-Modern, and that generality applies as much to sculpture and painting as it does to architecture. The door is wide open, as it was in the 1920s when Modernism had knocked down the previous academic barriers; the irony is that today's old-time Modernists are determined to be just as paranoic, reactionary and repressive as their Beaux-Arts persecutors were before them. Indeed the slurs against Post-Modernists occasionally sound like the Nazi and academic vitriol poured on Le Corbusier and Walter Gropius in the 1920s. Is history repeating itself in reverse? I'm not sure, but I do believe that these characterisations have not done what they were supposed to do – stem the tide of Post-Modernism – but rather have helped blow it up into a media event. My nightmare is that suddenly the reactionaries will become nice and civil. Everyone, but particularly the press, loves an abusive argument carried on by professors and the otherwise intelligent: it's always entertaining even if it obscures as much as it explains. And what it has hidden are the root causes of the movement.

[5] Philip Johnson and John Burgee, The AT&T Building, 1978-82, the building first branded as a Chippendale-Highboy became a monumental focus for Post-Modern loathing; today it seems a rather mellow New York skyscraper. (C. Jencks)

13 Aldo van Eyck, 'RPP – Rats, Posts and Other Pests', 1981 RIBA Annual Discourse published in *RIBA Journal*, *Lotus* and most fully in *AD News*, 7/81, London 1981, pp. 14-16.

14 Berthold Lubetkin, 'Royal Gold Medal Address', RIBA, *Transactions* II, Vol. 1, No. 2, London 1982, p. 48.

15 Berthold Lubetkin, 'RIBA President's Invitation Lecture', 11 June 1985, unpublished manuscript, p. 13. Published in part in *Building Design Magazine*, London. The comparison is with Stalin's giving Corinthian columns to the people. The Prince of Wales provokes the following memory: 'I can't help recalling the diktat of Stalin fifty years ago when he said "The assumption that the specialists know better drags theory and practice into the bog of reactionary cosmopolitan opinion." The proletariat acquired the right to have their Corinthian colonnades. . . '

16 'Is Post-Modern Architecture Serious?': Paolo Portoghesi and Bruno Zevi in Conversation', *Architectural Design*, 1/2 1982, pp. 20-1, originally published in Italian in *L'Espresso*.

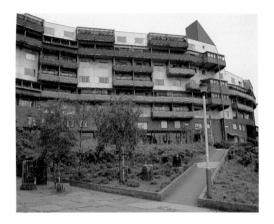

[6] Ralph Erskine, Byker Wall, Newcastle, 1974. Some of the first Post-Modern housing was *ad hoc* and vernacular in style making use, as here, of traditional and modern materials, green stained wood, brick, corrugated metal and asbestos. The emphasis on participation, with design acknowledging the tastes of the inhabitants, has remained a constant social goal of Post-Modernists. (Photo C. Jencks)

[7] Venturi and Rauch, Franklin Court, Philadelphia, 1972-6. Robert Venturi and Denise Scott Brown took up the lessons of Pop art: the goal was a legible architecture understood in a mass-culture. Here Benjamin Franklin's house is 'ghosted' in stainless steel, a Pop icon of the past set above his preserved memorabilia and sayings on plaques. (Photo Venturi and Rauch)

[8] Venturi Rauch and Scott Brown, Gordon Wu Dining Hall, Princeton, New Jersey, 1981-3. Along with James Stirling's Neue Staatsgalerie and Michael Graves' Humana Building this work ranks as one of the first mature buildings of Post-Modernism. It uses Modern elements, such as the strip window, and traditional signs, such as the Serliana, in a functional, symbolic and ironic manner. (Photo C. Jencks)

[9] Robert Krier, Ritterstrasse Apartments, Berlin-Kreuzberg, 1977-81. The white social housing of the Modernists is here adapted in a palazzo U-shaped block to form part of a perimeter block and positive urban space. Modern technology and imagery is mixed with a traditional typology, a typical double coding. (Photo Gerald Blomeyer)

17 My own writing and lecturing on Post-Modernism in architecture started in 1975 and 'The Rise of Post-Modern Architecture' was published in a Dutch book and a British magazine, *Architecture – Inner Town Government*, Eindhoven, July 1975, and *Architecture Association Quarterly*, No. 4, 1975. Subsequently Eisenman and Stern started using the term and by 1977 it had caught on. For a brief history see the 'Footnote on the Term' in *The Language of Post-Modern Architecture*, fourth edition, Academy Editions, London/Rizzoli, New York 1984, p. 8.

II Post-Modernism Defined

Post-Modernism, like Modernism, varies for each art both in its motives and time-frame, and here I shall define it just in the field with which I am most involved – architecture. The responsibility for introducing it into the architectural subconscious lies with Joseph Hudnut who, at Harvard with Walter Gropius, may have wished to give this pioneer of the Modern Movement a few sleepless nights. At any rate, he used the term in the title of an article published in 1945 called 'the post-modern house' (all lower case, as was Bauhaus practice), but didn't mention it in the body of the text or define it polemically. Except for an occasional slip here and there, by Philip Johnson or Nikolaus Pevsner, it wasn't used until my own writing on the subject which started in 1975.[17] In that first year of lecturing and polemicising in Europe and America, I used it as a temporising label, as a definition to describe where we had left rather than where we were going. The observable fact was that architects as various as Ralph Erskine, Robert Venturi, Lucien Kroll, the Krier brothers and Team Ten had all departed from Modernism and set off in different directions which *kept a trace of their common departure*. To this day I would define Post-Modernism as I did in 1978 as *double coding: the combination of Modern techniques with something else (usually traditional building) in order for architecture to communicate with the public and a concerned minority, usually other architects*. The point of this double coding was itself double. Modern architecture had failed to remain credible partly because it didn't communicate effectively with its ultimate users – the main argument of my book *The Language of Post-Modern Architecture* – and partly because it didn't make effective links with the city and history. Thus the solution I perceived and defined as Post-Modern: an architecture that was professionally based *and* popular as well as one that was based on new techniques *and* old patterns. Double coding to simplify means both elite/popular and new/old and there are compelling reasons for these opposite pairings. Today's Post-Modern architects were trained by Modernists, and are committed to using contemporary technology as well as facing current social reality. These commitments are enough to distinguish them from revivalists or traditionalists, a point worth stressing since it creates their hybrid language, the style of Post-Modern architecture. The same is not completely true of Post-Modern artists and writers who may use traditional techniques of narrative and representation in a more straightforward way. Yet all the creators who could be called Post-Modern keep something of a Modern sensibility – some intention which distinguishes their work from that of revivalists – whether this is irony, parody, displacement, complexity, eclecticism, realism or any number of contemporary tactics and goals. As I mentioned in the foreword, Post-Modernism has the essential double meaning: the continuation of Modernism and its transcendence.

The main motive for Post-Modern architecture is obviously the social failure of Modern architecture, its mythical 'death' announced repeatedly

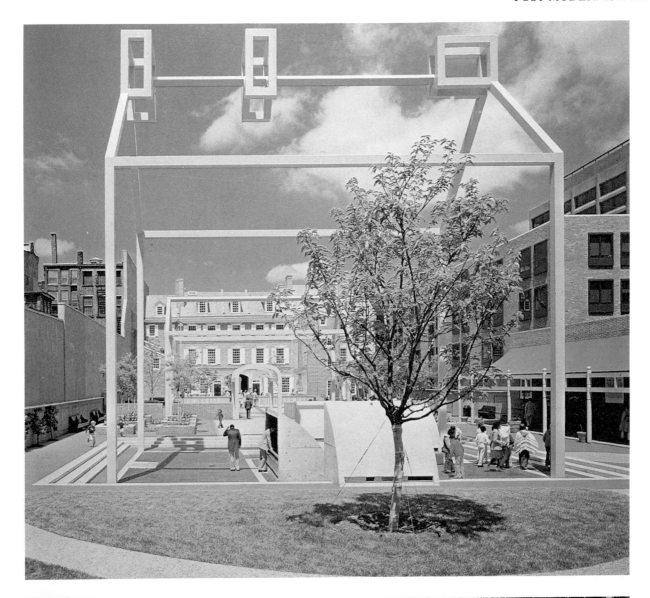

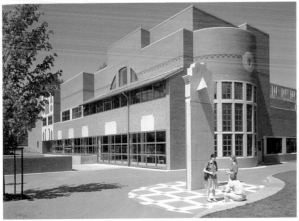

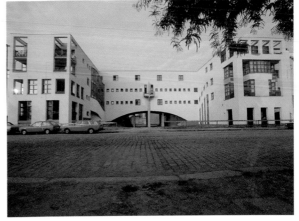

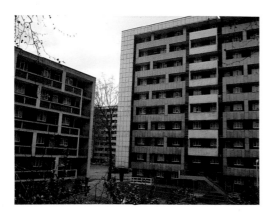

[10] Berthold Lubetkin and Tecton, Hallfield Estate Housing, London, 1947-55. The typology of Le Corbusier's 'City in the Park' led to an urbanism which was first criticised by Jane Jacobs in 1961 and then later by a chorus of writers including Robert Goodman, Oscar Newman, Rob Krier, Colin Ward and, recently, Alice Coleman. Lack of personal 'defensible space' represents just one of the problems of this typology; scale, density, and symbolism are equally questionable. (Photo C. Jencks)

[11] James Stirling, Michael Wilford and Associates, Neue Staatsgalerie, Stuttgart, 1977-84. 'Ruins in the Garden', classical blocks which have fallen about in an eighteenth-century manner, reveal the reality of Post-Modern construction: a steel frame holds up the slabs of masonry, and there is no cement between the blocks, but rather air. These holes in the walls, which are ironic vents to the parking garage, dramatise the difference between truth and illusion, and allow Stirling to assert continuity with the existing classical fabric while also showing the differences. Paradox and double coding exist throughout this scheme, which is more an articulation of urban tissue than a conventional building. (Photo C. Jencks)

18 Umberto Eco, *Postscript to The Name of the Rose*, Harcourt Brace Jovanovich, New York 1984, pp. 67-8.

over ten years. In 1968, an English tower block of housing, Ronan Point, suffered what was called 'cumulative collapse' as its floors gave way after an explosion. In 1972, many slab blocks of housing were intentionally blown up at Pruitt-Igoe in St Louis. By the mid 1970s, these explosions were becoming a quite frequent method of dealing with the failures of Modernist building methods: cheap prefabrication, lack of personal 'defensible' space and the alienating housing estate. The 'death' of Modern architecture and its ideology of progress which offered technical solutions to social problems was seen by everyone in a vivid way. The destruction of the central city and historical fabric was almost equally apparent to the populace and again these popular, social motives should be stressed because they aren't quite the same in painting, film, dance or literature. There is no similar, vivid 'death' of Modernism in these fields, nor perhaps the same social motivation that one finds in Post-Modern architecture. But even in Post-Modern literature there is a social motive for using past forms in an ironic way. Umberto Eco has described this irony or double coding: 'I think of the postmodern attitude as that of a man who loves a very cultivated woman and knows he cannot say to her, "I love you madly", because he knows that she knows (and that she knows that he knows) that these words have already been written by Barbara Cartland. Still, there is a solution. He can say, "As Barbara Cartland would put it, I love you madly". At this point, having avoided false innocence, having said clearly that it is no longer possible to speak innocently, he will nevertheless have said what he wanted to say to the woman: that he loves her, but he loves her in an age of lost innocence. If the woman goes along with this, she will have received a declaration of love all the same. Neither of the two speakers will feel innocent, both will have accepted the challenge of the past, of the already said, which cannot be eliminated, both will consciously and with pleasure play the game of irony . . . But both will have succeeded, once again, in speaking of love.'[18]

Thus Eco underlines the lover's use of Post-Modern double coding and extends it, of course, to the novelist's and poet's social use of previous forms. Faced with a restrictive Modernism, a minimalism of means and ends, writers such as John Barth have felt just as restricted as architects forced to build in the International Style, or using only glass and steel. The most notable, and perhaps the best, use of this double coding in architecture is James Stirling's addition to the Staatsgalerie in Stuttgart. Here one can find the fabric of the city and the existing museum extended in amusing and ironic ways. The U-shaped palazzo form of the old gallery is echoed and placed on a high plinth, or 'Acropolis', above the traffic. But this classical base holds a very real and necessary parking garage, one that is ironically indicated by stones which have 'fallen', like ruins, to the ground. The resultant holes show the real construction – not the thick marble blocks of the real Acropolis, but a steel frame holding stone cladding which allows the air ventilation required by law. One can sit on these false ruins and ponder the truth of our lost innocence: that we live in an age which can build

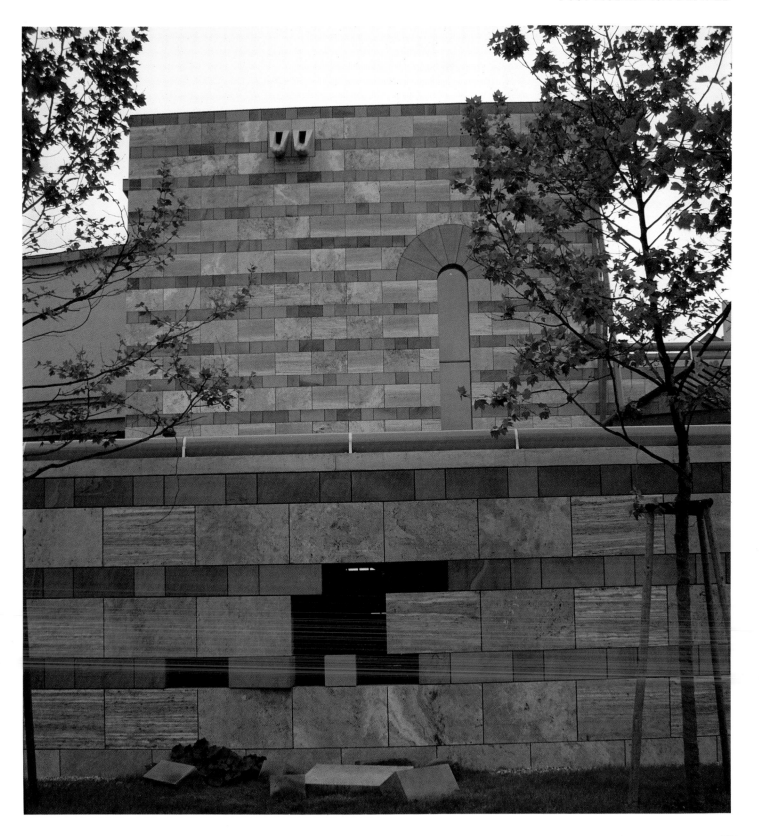

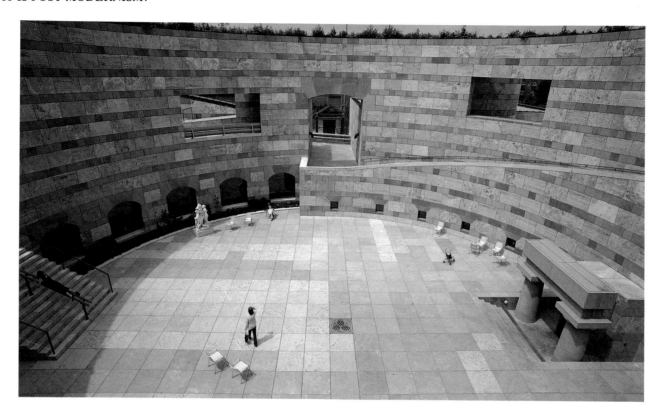

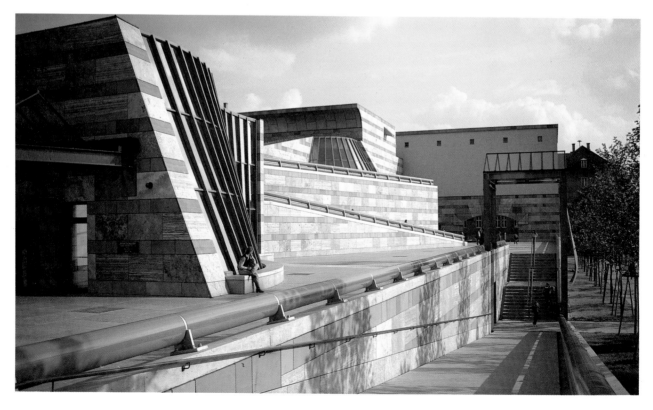

with beautiful, expressive masonry as long as we make it skin-deep and hang it on a steel skeleton. A Modernist would of course deny himself and us this pleasure for a number of reasons: 'truth to materials', 'logical consistency', 'straightforwardness', 'simplicity' – all the values and rhetorical tropes celebrated by such Modernists as Le Corbusier and Mies van der Rohe.

Stirling, by contrast and like the lovers of Umberto Eco, wants to communicate more and different values. To signify the permanent nature of the museum, he has used traditional rustication and classical forms including an Egyptian cornice, an open-air Pantheon, and segmental arches. These are beautiful in an understated and conventional way, but they aren't revivalist either because of small distortions, or the use of a modern material such as reinforced concrete. They say, 'We are beautiful like the Acropolis or Pantheon, but we are also based on concrete technology and deceit.' The extreme form of this double coding is visible at the entry points: a steel temple outline which announces the taxi drop-off point, and the Modernist steel canopies which tell the public where to walk in. These forms and colours are reminiscent of De Stijl, that quintessentially modern language, but they are collaged onto the traditional background. Thus Modernism confronts Classicism to such an extent that both Modernists and Classicists would be surprised, if not offended. There is not the simple harmony and consistency of either language or world view. It's as if Stirling were saying through his hybrid language and uneasy confrontations that we live in a complex world where we can't deny either the past and conventional beauty, or the present and current technical and social reality. Caught between this past and present, unwilling to oversimplify our situation, Stirling has produced the most 'real' beauty of Post-Modern architecture to date.

As much of this reality has to do with taste as it does with technology. Modernism failed as mass-housing and city building partly because it failed to communicate with its inhabitants and users who might not have liked the style, understood what it meant or even known how to use it. Hence the double coding, the essential definition of Post-Modernism, has been used as a strategy of communicating on various levels at once. Virtually every Post-Modern architect – Robert Venturi, Hans Hollein, Charles Moore, Robert Stern, Michael Graves, Arata Isozaki are the notable examples – use popular *and* elitist signs in their work to achieve quite different ends, and their styles are essentially hybrid. To simplify, at Stuttgart the blue and red handrails and vibrant polychromy fit in with the youth that uses the museum – they literally resemble their dayglo hair and anoraks – while the Classicism appeals more to the lovers of Schinkel. This is a very popular building with young and old and when I interviewed people there – a group of *plein air* painters, schoolchildren and businessmen – I found their different perceptions and tastes were accommodated and stretched. The pluralism which is so often called on to justify Post-Modernism is here a tangible reality.

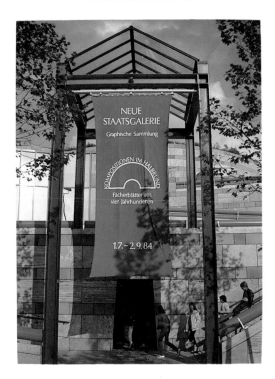

[14] Neue Staatsgalerie. The taxi drop-off point is emphasised by a large steel canopy, a foursquare 'primitive hut' made from the typical Doric of our time, the I-beam. The architecture draws in quite different media: handrails are continuously used as slides and colourful anoraks and clothing seem a part of the design. (Photo C. Jencks)

[12] Neue Staatsgalerie. The sculpture court, a transformation of the Pantheon and Hadrian's Villa among other classical types, is a true *res publica* with the public brought through the site on a curvilinear walkway to the right. Traditional and Modern 'language games' are not synthesised but rather juxtaposed in tension, an allegory of a schizophrenic culture. (Photo C. Jencks)

[13] Neue Staatsgalerie. The 'Acropolis' perched on a garage shows further aspects of the discontinuous pluralism which J.F.Lyotard and others see as a defining aspect of Post-Modernism. Oddly the role of ornament is taken on by Modernist forms: function by traditional ones. This ironic reversal of twentieth-century convention implies a new set of standards which throws in doubt both Neo-Classical and Modern aesthetics. (Photo C. Jencks)

[15] Leon Krier, *The Completion of Washington DC*, 1985, aerial perspective. L'Enfant's Baroque plan of Washington is finally filled out and given the fabric which the monuments so desperately need. Four large towns, based on a traditional typology of small blocks, give the density and measure to urban life which Modernist schemes have lost. It looks nostalgic at first and then one realises that the relation between parts – monument and infill, courtyard and street, living and work areas – is an optimum achieved in few periods; with the Roman castrum and occasionally in the Renaissance and eighteenth-century France. Krier's use of the past to challenge the present – especially the suburban, agoraphobic present that is Washington DC – is as pertinent as his notion of the 'Masterplan as Constitution', and it's far better than Le Corbusier's notion of the 'Plan as Dictator'. (Courtesy of Leon Krier)

[16] Leon Krier, *View of the Nation's Capitol*, 1985. This megabuilding is 'improved' by being brought down to the ground by flights of steps which anchor it in a public piazza, and by being broken up into grammatical parts. The wings are now visually separated from the centre by planting and so do not form a run-on sentence. This Corbusian perspective, taken from his typical Parisian terrace with outdoor café, invests Washington with a much-needed urbanity. Although the arcades to either side are not being built, Jaquelin Robertson, an urbanist sympathetic to Krier, has recently completed one block near the Capitol which shows the virtues of this typology. (Courtesy of Leon Krier)

19 Besides my own *The Language of Post-Modern Architecture*, *op. cit.*, and *Current Architecture*, Academy Editions, London/Rizzoli, New York 1982, and *Modern Movements in Architecture*, second edition, Penguin Books, Harmondsworth, 1985, see Paolo Portoghesi, *After Modern Architecture*, Rizzoli, New York 1982, and its updated version, *Postmodern*, Rizzoli, New York 1983, and *Immagini del Post-Moderno*, Edizioni Chiva, Venice 1983. See also Heinrich Klotz, *Die Revision der Moderne, Postmoderne Architektur, 1960-1980* and *Moderne und Postmoderne Architektur der Gegenwart 1960-1980*, Friedr. Vieweg & Sohn, Braunschweig/Wiesbaden 1984. We have debated his notion of Post-Modern architecture as 'fiction' and this has been published in *Architectural Design* 7/8 1984, *Revision of the Modern*. See also my discussion of users and abusers of Post-Modern in 'La Bataille des étiquettes', *Nouveaux plaisirs d'architecture*, Centre Georges Pompidou, Paris 1985, pp. 25-33.

This is not the place to recount the history of Post-Modern architecture, but I want to stress the ideological and social intentions which underlie this history because they are so often overlooked in the bitter debate with Modernists.[19] Even traditionalists often reduce the debate to matters of style, and thus the symbolic intentions and morality are overlooked. If one reads the writings of Robert Venturi, Denise Scott Brown, Christian Norberg-Schulz, or myself, one will find the constant notion of pluralism, the idea that the architect must design for different 'taste cultures' (in the words of the sociologist Herbert Gans) and for differing views of the good life. In any complex building, in any large city building such as an office, there will be varying tastes and functions that have to be articulated and these will inevitably lead, if the architect follows these hints, towards an eclectic style. He may pull this heterogeneity together under a Free-Style Classicism, as do many Post-Modernists today, but a trace of the pluralism will and should remain. I would even argue that 'the true and proper style' is not as they said Gothic, but some form of eclecticism, because only this can adequately encompass the pluralism that is our social and metaphysical reality.

Many people would disagree with this last point and some of them, such as the visionary and urbanist Leon Krier, are almost Post-Modern. I bring him up as a borderline case and because he shows how different traditions may influence each other in a positive way. Krier worked for James Stirling in the early 1970s and since then has evolved his own form of Vernacular Classicism. In his schemes for the reconstruction of cities such as Berlin and Washington DC, he shows how the destroyed fabric of the historic city could be repaired and a traditional set of well-scaled spaces added to this core. The motivations are urbanistic and utopian (in the sense that they are unlikely to be realised). They are also traditional and idealistic in the straightforward manner that Post-Modernism is not. The way of life implied is paternalistic and monistic, but the plans would entail not the totalitarianism that his critics aver when they compare him with Albert Speer but an integrated culture led by a determined and sensitive elite. In this sense, Krier hasn't lost the innocence which Umberto Eco and the Post-Modernists believe is gone for good, but has returned to a pre-industrial golden age where singular visions could be imagined for everyone. Again, critics will say he's kept his innocence precisely because he hasn't built and faced the irreducibly plural reality.

This may be true and yet Krier has had a beneficent effect on Post-Modernists, as on others, because his ideal models act as a critique of current planning in the same way as do such surviving fragments as the centres of Siena and Venice. His nostalgia, like that of the French Revolution, is of a very positive and creative kind because it shows what a modern city might be if built with traditional streets, arcades, lakes and squares. Moreover – and this does make him a Post-Modernist – his drawing manner, derived equally from Le Corbusier and the École des Beaux-Arts, is based on practical urban knowledge. He is not simply a

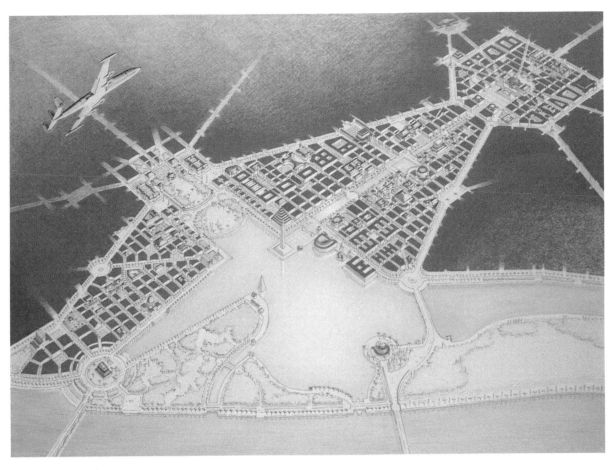

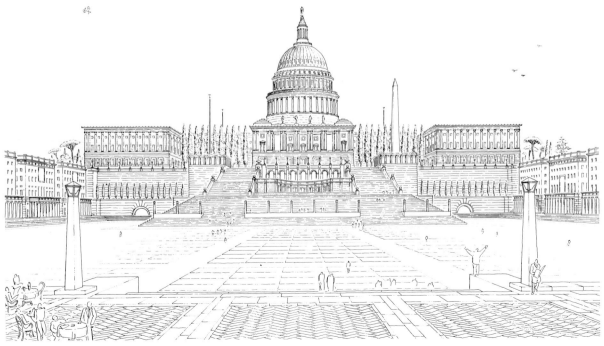

[17] Sandro Chia, *Three Boys on a Raft*, 1983, oil on canvas, 97 x 111in. The re-use of Italian Futurist and mythlogical themes and techniques, borrowing freely from Mediterranean traditions which are chosen and combined for their secondary meanings. (Zindman/Fremont, Paine Weber Inc., Courtesy of Leo Castelli Gallery, New York)

[18] Evolutionary Tree of Post-Modern Architecture, 1960-1980. In any major movement there are various strands running concurrently which have to be distinguished because of differing values. Here the six main traditions of Post-Modernism show their common ground and differences and illustrate the fact that since the late 1970s Post-Modern Classicism and urbanism have been unifying forces.

20 Anthony Blunt, *Some Uses and Misuses of the Terms Baroque and Rococo as applied to Architecture*, Oxford 1973; Charles Jencks, *Late-Modern Architecture*, Academy Editions, London/Rizzoli, New York 1980, p. 32.

mannerist, sprinkling bi-planes and 1920s technology through the sky, but someone who thinks through all the public buildings and private fabric before he draws. His bi-planes are of course ironic Post-Modern comments on the desirability of technical regression.

There are, inevitably, many more strands of Post-Modern architecture than the two major ones which the work of Stirling and Krier represent, and I have tried to show the plurality as consisting of six basic traditions or 'species'. There is some overlap between these identifiable species, within the evolutionary tree of my diagram, and architects, unlike animals, can jump from one category to another, or occupy several strands at once. The diagram shows two fundamental aspects which have to be added to our former definition of Post-Modernism: it is a movement that starts *roughly in 1960 as a set of plural departures from Modernism*. Key definers are a pluralism both philosophical and stylistic, and a dialectical or critical relation to a pre-existing ideology. There is no one Post-Modern style, although there is a dominating Classicism, just as there was no one Modern mode, although there was a dominating International Style. Furthermore, if one is going to classify anything as complex as an architectural movement, one has to use *many* definers: Anthony Blunt, in a key text on Baroque and Rococo, shows the necessity for using ten definers, and in distinguishing Post-Modernism from Modern and Late-Modern architecture, I have used thirty.[20] Most of these definers concern differences over symbolism, ornament, humour, technology and the relation of the architect to existing and past cultures. Modernists and Late-Modernists tend to emphasise technical and economic solutions to problems, whereas Post-Modernists tend to emphasise contextual and cultural additions to their inventions.

Many of these points could be made about Post-Modern art. It also started roughly in 1960 with a succession of departures from Modernism – notably Pop Art, Hyperrealism, Photo Realism, Allegorical and Political Realism, New Image Painting, *La Transavanguardia*, Neo-Expressionism and a host of other more or less fabricated movements. Pressure from the art market to produce new labels and synthetic schools has, no doubt, increased the tempo and heat of this change. And the influence of the international media, so emphasised as a defining aspect of the post-industrial society, has made these movements cross over national boundaries. Post-Modern art, like architecture, is influenced by the 'world village' and the sensibility that comes with this: an ironic cosmopolitanism. If one looks at three Italian Post-Modernists, Carlo Maria Mariani, Sandro Chia and Mimmo Paladino, one sees their 'Italianness' always in quotation marks, an ironic fabrication of their roots made as much for the New York they occasionally inhabit as from inner necessity. Whereas a mythology was given to the artist in the past by tradition and by patron, in the Post-Modern world it is chosen and invented.

Mariani, in the mid 1970s, created his fictional academy of eighteenth-century peers – Goethe, Winckelmann, Mengs, etc – and then painted

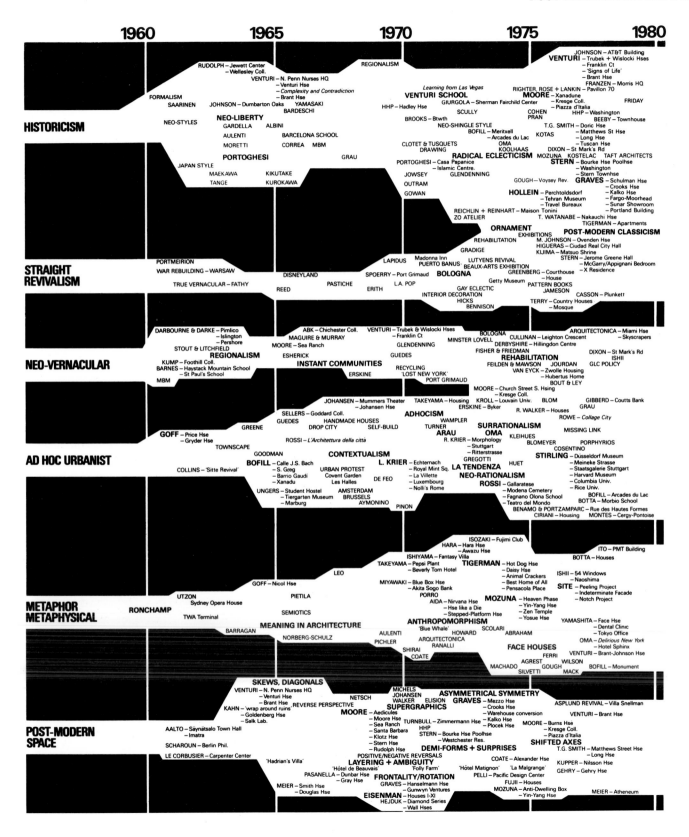

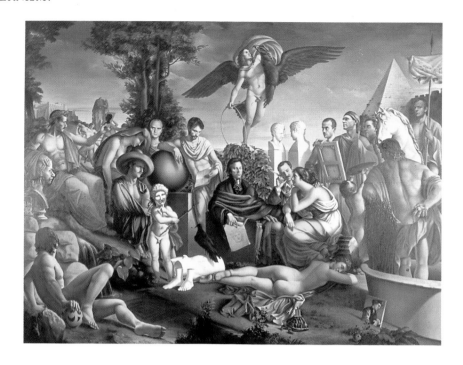

some missing canvasses to fill out a mythic history. In the early 1980s he transferred this mythology to the present day and painted an allegory of Post-Modern Parnassus with friends, enemies, critics and dealers collected around himself in the centre – a modern-day version of Raphael's and Meng's versions of the traditional subject. We see here a series of texts layered one on top of another as an enigmatic commentary, like the structure of a myth. Is it serious, or parody, or more likely, the combination ironic allegory? The facial expressions and detail would suggest this double reading. Mariani both solemn and supercilious sits below Ganymede being abducted to heaven by Zeus: Ganymede is not only the beautiful boy of Greek mythology being captured in the erotic embrace of the eagle Zeus, but a portrait of the performance artist Luigi Ontani, hence the hoop and stick. To the right, Francesco Clemente gazes past a canvas held by Sandro Chia; Mario Merz is Hercules in an understated bathtub; a well-known New York dealer waddles to the water personified as a turtle; critics write and admire their own profiles. All this is carried out in the mock heroic style of the late eighteenth century, the style of *la pittura colta* which Mariani has made his own. No one who gives this 'cultured painting' an extended analysis would call it eighteenth-century, or straight revivalist, although many critics unsympathetic to Post-Modernism have again branded the work as 'fascist'. The representational conventions had been dismissed by Modernists as taboo, as frigid academic art.

If Mariani adapts and invents his mythology then so do many Post-Modernists who are involved in allegory and narrative. This concern for content and subject matter is in a sense comparable to architects' renewed concern for symbolism and meaning. Whereas Modernism and particularly Late-Modernism concentrated on the autonomy and expression of the individual art form – the aesthetic dimension – Post-Modernists focus on the semantic aspect. This generalisation is true of such different artists as David Hockney, Malcolm Morley, Eric Fischl, Lennart Anderson and Paul Georges, some of whom have painted enigmatic allegories, others a combination of sexual and classical narratives. The so-called 'return to painting' of the 1980s is also a return to a traditional concern with content, although it is content with a difference from pre-Modern art.

First, because these Post-Modernists have had a Modern training, they are inevitably concerned with abstraction and the basic reality of modern life, that is, a secular mass-culture dominated by economic and pragmatic motives. This gives their work the same complexity, mannerism and double coding present in Post-Modern architecture, and also an eclectic or hybrid style. For instance Ron Kitaj, who is the artist most concerned with literary and cultural subject matter, combines Modernist techniques of collage and a flat, graphic composition with Renaissance traditions. His enigmatic allegory *If Not, Not* is a visual counterpart of T.S. Eliot's *The Wasteland*, on which it is partly based. Survivors of war crawl through the desert towards an oasis, survivors of civilisation (Eliot himself) are

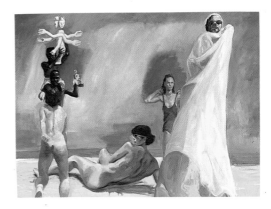

[21] Eric Fischl, *A Brief History of North Africa*, 1985, oil on linen, 88 x 120in. Fischl explores archetypal scenes – the beach, the suburban backyard, the bedroom – for their latent violence and sexuality. The atmosphere is often charged with a dissociated passion that reveals the vulnerability of character and the ambiguity of political and social roles. (Courtesy of Mary Boone Gallery, New York)

[19] Carlo Maria Mariani, *Costellazioni del Leone (La Scuola di Roma)*, 1980-1, oil on canvas, 134 x 178in. An elaborate allegory on the current Post-Modern School of Rome – one part eighteenth-century pastiche, one part critical satire. (Courtesy of Sperone Westwater Gallery, New York)

[20] Ron Kitaj, *If Not, Not*, 1975-6, oil on canvas, 60 x 60in. The most serious Post-Modern painter often used Modernist themes and characters as a departure point for his fractured allegories. These sustain a mood of catastrophe and mystery which is alleviated by small emblems of hope and a haunting beauty. (Courtesy of Scottish National Gallery of Modern Art)

engaged in quizzical acts, some with representatives of exotic culture. Lamb, crow, palm tree, turquoise lake, and a Tuscan landscape consciously adapted from the classical tradition resonate with common overtones. They point towards a western and Christian background overlaid by Modernism, the cult of primitivism and disaster. The classical barn/monument at the top, so reminiscent of Aldo Rossi and Post-Modern face buildings, also suggests the death camps, which it represents. Indeed the burning inferno of the sky, the corpse and broken pier, the black and truncated trees all suggest life after the Second World War: plural, confused and tortured on the whole, but containing islands of peace (and a search for wholeness). The title, with its double negative – *If Not, Not* – was taken from an ancient political oath which meant roughly: if you the King do not uphold our liberties and laws, then we do not uphold you. Thus the consequences of broken promises and fragmented culture are the content of this gripping drama, one given a classical *gravitas* and dignity.

Examples could be multiplied of this type of hidden moralistic narrative: Robert Rauschenberg, David Salle, Hans Haacke, Ian Hamilton Finlay and Stephen McKenna all make use of the classical tradition in portraying our current cultural situation. Their political and ethical views are often opposed, but their intention to revive the tradition of moralistic art is shared. Thus the definition of Post-Modernism that I've given above for architects also holds true for artists and, I believe, such literary figures as Umberto Eco, David Lodge, John Barth, John Gardner and Jorge Luis Borges among many others. It does not hold true, however, for so many artists lumped together under a Post-Modern label for whom there are much better appellations.

III Modern and Late-Modern Defined

The Modern Movement, as I've suggested, was in architecture a Protestant Reformation putting faith in the liberating aspects of industrialisation and mass-democracy. Le Corbusier pursued his 'crusade', as he called it, for 'a new spirit', as he also called it, and his reformed religion was meant to change the public's attitude towards mass-production. So convinced was this prophet of the beneficent effects of a well-designed environment that he ended his bible – *Towards a New Architecture* – with the exhortation: 'Architecture or Revolution. Revolution can be avoided.' Walter Gropius, another militant saint of the Design Reformation, founded the Bauhaus as a 'cathedral of the future' and in 1923 declared the standard doctrine: 'art and technology: a new unity'. Mies van der Rohe made any number of pleas to the Spirit of the Age, the *Zeitgeist* of the new industrialisation, and proclaimed that it could solve all our problems, even 'social, economic and artistic' ones.[21]

In short, the three leading Modern architects didn't just practise a

[23] Ian Hamilton Finlay, *Nuclear Sail*, 1974, slate with John Andrew. The ambiguous beauty of war machines is often a departure point for Finlay's combination of emblem, writing and sculpture. Here the black 'sail' of a Polaris submarine stands against an artificial lake with the title engraved beside it: the ambiguity of the sail/coning tower is thus extended to that of a dolmen and black tombstone. Terror and virtue, destruction and beauty, are two sides to Finlay's art as in military iconography. (Photo C. Jencks)

[22] Ian Hamilton-Finlay, *Adorno's Hut*, 1986-7, with Andrew Townsend and Keith Brookwell. The primitive Hut, 'Adam's House in Paradise', as it might be seen by the philosopher Adorno in transformation between nature and culture, the origins of architecture in trees and brachiated structure and its culmination in the classical, steel temple. The series of oppositions and transformations becomes for Finlay a didactic function of art. (Antonia Reeve)

21 Ludwig Mies van der Rohe, 'Industrialized Building', 1924, reprinted in *Programmes and Manifestos on 20th-Century Architecture*, Lund Humphries, London 1970, p. 81.

[24] Alvar Aalto, Tuberculosis Sanatorium, Paimio, Finland, 1933. The most appropriate and successful use of the International Style was on hospitals and occasionally, in Germany, Finland and Switzerland, on workers' housing. With its open-air communal block set amid the pine trees giving the patients salubrious views of nature, and its careful detailing and construction, the Paimio Sanatorium has turned institutional imagery into a heroic reality. (Photos D. Porphyrios)

common, Protestant style, but also believed that if their faith were to govern industrialisation then it could change the world for the better, both physically and spiritually. This religion of Modernism triumphed throughout the globe as it was disseminated by the saints and proselytisers – Sir Nikolaus Pevsner, Sir James Richards, Sir Leslie Martin, with the bible according to Siegfried Giedion, *Space, Time and Architecture*. Modern academies were formed at the major universities such as Cambridge and Harvard and from there the Purist doctrines of John Calvin Corbusier, Martin Luther Gropius and John Knox van der Rohe were dispersed. Their white cathedrals, the black and white boxes of the International Style, were soon built in every land, and for a while the people and professors kept the faith. Ornament, polychromy, metaphor, humour, symbolism and convention were put on the Index and all forms of decoration and historical reference were declared taboo. We are all well acquainted with the results – 'the architecture of good intentions' – as Colin Rowe termed them, and there are a lot of pleasant white housing estates and machine-aesthetic hospitals to prove that the intentions were not all misguided.

The reigning religion of architectural Modernism could be called pragmatic amelioration, that is the belief that by 'doing more with less' as Buckminster Fuller said, social problems would slowly disappear. Technical progress, in limited spheres such as medicine, seems to bear out this ideology, still a dominant one of Late-Modernists.

Thus we might define Modern architecture as the *universal, international style stemming from the facts of new constructional means, adequate to a new industrial society, and having as its goal the transformation of society, both in its taste and social make-up.* But there is an anomaly in this Modernism which is both overwhelming and missed by commentators on the subject. It is the direct opposite of the more widespread Modernism in the other arts and philosophy; for these are *not* optimistic and progressivist at all. Think of Nietzsche, Goedel, Heisenberg, Heidegger and Sartre – closer to nihilism than to the positivism of Fuller. Or think of Yeats, Joyce, Pound, T.S. Eliot, or De Chirico, Picasso, Duchamp and Grosz – hardly liberal, not very socialist and certainly not optimistic. Whereas Modernism in architecture has furthered the ideology of industrialisation and progress, Modernism in most other fields has either fought these trends or lamented them. In two key areas, however, the various Modernisms agree and that is over the value of abstraction and the primary role of aesthetics, or the perfection of the expressive medium. Modernism as Clement Greenberg has defined it always has this irreducible goal: to focus on the essence of each art language. By doing this, he argues, standards are kept high in an age of secularisation, where there are few shared values and little left of a common symbolic system. All one can do in an agnostic age of consumer pluralism is sharpen the tools of one's trade, or 'purify the language of the tribe', as Mallarmé and T.S. Eliot defined the poet's role.

This idea relates closely to the nineteenth-century notion of the avant-garde, and Modernism is based, of course, on the myth of a romantic advance guard setting out before the rest of society to conquer new territory, new states of consciousness and social order. The metaphor of the avant-garde as a political and artistic military was formulated in the 1820s and although there were very few artists who were politically active, like Gustave Courbet, and even fewer that were agitating politically, like Marinetti, the myth of social activism sustained an elevated role for what was becoming a patronless class. Artists, like architects, were often underemployed and at the mercy of a heartless, or at least uninterested, economic system. Where before they had a defined social relationship to a patron – the State, Church or an individual – now they related to a marketplace that was competitive and agnostic.

One can thus see Modernism as the first great ideological response to this social crisis and the breakdown of a shared religion. Faced with a post-Christian society, the intellectuals and the creative elite formulated a new role for themselves, inevitably a priestly one. In their most exalted role, they would heal society's rifts; in 'purifying the language of the tribe', they could purify its sensibility and provide an aesthetic-moral base – if not a political one. From this post-Christian role developed two positions and a contradiction between them that has caused much confusion. To deal with this confusion I shall resort, as others such as Frank Kermode and Robert Stern have done, to two technical terms because the word 'modern' hides at least two different meanings.[22]

There is the healing role of the artist, that of overcoming the 'split between thinking and feeling' which T.S. Eliot and Siegfried Giedion located in the nineteenth century, and this leads to what has been called 'Heroic Modernism'. Then there is the subversive and romantic role of the artist to conquer new territory, 'to make it new', to make art different, difficult, self-referential and critical: what I would call 'Agonistic Modernism'. These two meanings relate to what Stern labels 'traditional versus schismatic Modernism', humanism versus agonism, continuity versus 'the shock of the new', optimism versus nihilism, and so on. For Stern and other writers such as Ihab Hassan, the second of the traditions – schismatic or resistant Modernism – has itself mutated into schismatic Post-Modernism. Thus Hassan writes: 'Post-Modernism, on the other hand, is essentially subversive in form and anarchic in its cultural spirit. It dramatizes its lack of faith in art even as it produces new works of art intended to hasten both cultural and artistic dissolution.'[23]

As examples Hassan mentions the literature of Genet and Beckett – what George Steiner calls the 'literature of silence' – the self-abolishing art of Tinguely and Robert Morris, the mechanistic and repetitive art of Warhol, the non-structural music of John Cage and the technical architecture of Buckminster Fuller.[24] All of this takes Early Modernism and its notion of radical discontinuity to an extreme leading to the hermeticism of the 1960s and 1970s. Because this later tradition was

22 The two basic strands of Modernism are discussed by many critics. See for instance Renato Poggioli, *The Theory of the Avant-Garde*, Harvard University Press, Cambridge, Mass. 1968. The discussion of Bradbury and McFarlane is particularly relevant; see their 'The Name and Nature of Modernism', in *Modernism 1890-1930* edited by Malcolm Bradbury and James McFarlane, Penguin Books, Harmondsworth 1976, pp. 40-1 and 46; Frank Kermode, 'Modernisms', in *Modern Essays*, London 1971. For architecture the best discussion is Robert Stern, 'The Doubles of Post-Modern', *The Harvard Architectural Review*, Vol. 1, Spring 1980 although, as my text makes clear, I would use the term Late-Modern for his 'Schismatic Post-Modern'.

23 Ihab Hassan, 'Joyce, Beckett, and the postmodern imagination', *Tri Quarterly*, XXXIV, Fall 1975, p. 200.

24 Ihab Hassan, *Paracriticisms: Seven Speculations of the Times*, University of Illinois Press, Urbana 1975, pp. 55-6.

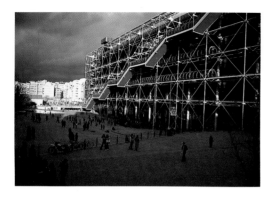

[25] Renzo Piano and Richard Rogers, Pompidou Centre, Paris 1971-7. The Modernist emphasis on structure, circulation, open space, industrial detailing and abstraction is taken to its Late-Modern extreme, although again often mis-termed Post-Modern. (Photo C. Jencks)

[26] Kevin Roche, John Dinkeloo and Associates, One UN Plaza, New York, 1974-6. Various Modernist skyscrapers are evident here and this faceted, skewed membrane of Kevin Roche. Termed Post-Modern by popular critics because of its distortions in scale, outline and mass, it is in fact typically Late-Modern. (Photo Kevin Roche, John Dinkeloo and Associates)

25 For references see *The Language of Post-Modern Architecture*, fourth edition, *op. cit.*, p. 8.

26 The work of Archigram and Richard Rogers was often termed Post-Modern in the late 1970s before critics began to understand the term and its distinction from High-Tech. Edward Lucie-Smith followed this usage in his book on Modernism published around this time.

27 'Post-Modernism', a symposium at the Institute for Architecture and Urban Studies, 1981, attended by Christian Hubert, Sherrie Levine, Craig Owens, David Salle and Julian Schnabel, later published in *Reallife*, 30 March 1981.

28 *The Anti-Aesthetic: Essays on Postmodern Culture*, edited by Hal Foster, Bay Press, Port Townsend, Washington 1983.

29 *ibid.*, p. 130.

30 *ibid.*, pp. 31-42. See also the anthology *Theories of Contemporary Art*, edited by Richard Hertz, Prentice Hall, New Jersey 1985, pp. 215-25. Post-Modernism is also discussed by various authors in a loose way in this anthology.

obviously different from the Heroic Modernism of the 1920s quite a few critics loosely applied the prefix 'post'. For instance the popular critics Paul Goldberger and Douglas Davis used it in the *New York Times* and *Newsweek* to discuss the ultra-Modern work of Hardy, Holzman and Pfeiffer, Cesar Pelli and Kevin Roche, all of which exaggerates the high-tech work of Mies and Le Corbusier.[25] The art critic Edward Lucie-Smith, like others, even applied it to Piano and Rogers' Pompidou Centre.[26] In short, Post-Modern meant *everything* that was different from High-Modernism, and usually this meant skyscrapers with funny shapes, brash colours and exposed technology. That such architects were against the pluralism, ornament and convention of Post-Modernism was missed by these critics. They just adopted a current phrase for discontinuity and lumped every departure under it.

The same permissive categorisation was practised in artistic theory and criticism and so when conferences were held on the subject artists were confused as to whether they were supporting the Post-Modern, or against it.[27] In fact a whole book, *The Anti-Aesthetic: Essays on Postmodern Culture*, was dedicated to this confusion.[28] Here the editor Hal Foster uses it to mean a cultural and political resistance to the status quo. For one of the contributors, Craig Owens, it is the critical use of post-industrial techniques (computers and photography) in art and the 'loss of master narratives' (he follows J.F. Lyotard in this). Frederic Jameson uses it as an umbrella term to cover all reactions to High-Modernism (again John Cage and William Burroughs), the levelling of distinctions between high- and mass-culture and two of its 'significant features' – pastiche and schizophrenia. Jean Baudrillard refers to it as epitomising our era and its 'death of the subject' caused basically by television and the information revolution. ('We live in the ecstasy of communication. And this ecstasy is obscene'.[29]) Most of the remaining authors use it in different ways, some of which have a relation to resisting or 'deconstructing' the common assumptions of our culture. In short, it means almost everything and thus nearly nothing.

Before I discuss this 'Nothing Post-Modernism' where very little is at stake, I'd like to mention one of its causes: the view that the word can be appropriated to mean any rupture with High-Modernism. Rosalind Krauss's essay 'Sculpture in the Expanded Field' printed in this and another anthology on Post-Modern art shows this appropriation.[30] Her elegant and witty essay seeks to define all departures from sculpture that appear to break down the category of Modernist sculpture – let us say Brancusi's *Endless Column* – and expand them to include such things as Christo's *Running Fence* and wrapped buildings, Robert Smithson's use of earth-covered mirrors in the Yucatan, a wooden maze by Alice Aycock constructed in 1972, and various earthworks and 'marked sites' such as a sunken, framed hole in the ground executed by Mary Miss in 1978.

Krauss uses a structuralist diagram to draw this expanded field of sculpture – the objects that are *not* architecture, *not* landscape, indeed *not* sculpture, and her wit consists in making the diagram itself expand to

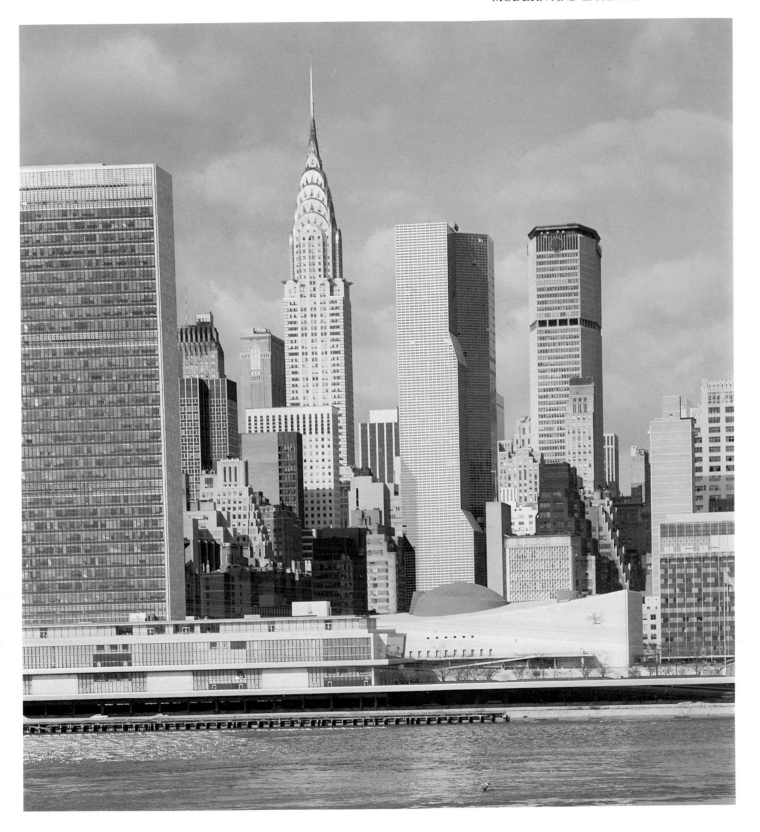

[27] Robert Morris, *Untitled,* 1970, brown felt, 72 x 216in, installed 96in high. Sculpture, as Rosalind Krauss defines it, becoming 'pure negativity: the combination of exclusions ... a kind of ontological absence'. Morris in the late 1960s reached some interestingly elegant dead ends such as here with the dark felt which, with its subtle logical twists, tells you it is 'not wall and not floor' but what's left over when you subtract these. (Courtesy of Saatchi Collection, London)

[28] Sol LeWitt, *Serial Project (A, B, C, D),* 1966, white stove enamel on aluminium, 36⅝ x 226¾ x 226¾in. A series of mechanical operations carried out by others lend these geometrical works an architectural flavour. Ultimately this automatic sculpture, like the architectural machines of Hiromi Fujii and Peter Eisenman, is very beautiful in the way its white grids pop up everywhere like rabbits. Why the series isn't titled *A, B, C, D, E, F,* as mathematically would seem to be implied, is a prop-position to contemplate. Conceptual and Minimalist art were both typical Late-Modern movements. (Courtesy of Saatchi Collection, London)

include a lot of combined 'nots'. The strategy is not dissimilar to the Modernist practice of defining things by what they are *not*, in order to maximise their differences and essentiality, but she presents their expansion as a 'rupture' with Modernism: '. . .One after another Robert Morris, Robert Smithson, Michael Heizer, Richard Serra, Walter de Maria, Robert Irwin, Sol LeWitt, Bruce Nauman (between 1968 and 1970) had entered a situation the logical conditions of which can no longer be described as modernist.'[31] In her diagrammatical, logical terms this is quite true, but then she goes on to make a false inference: 'In order to name this historical rupture and the structural transformation of the cultural field that characterizes it, one must have recourse to another term. The one already in use in other areas of criticism is postmodernism. There seems no reason not to use it.'

Oh yes there is *not*, to use the not-way of not-definition, for if one thing is not obscure it is that you can't define things usefully by what they are not. All the *things* in a room that are not men are not necessarily women: there is a near infinity of other classes of things. And those artists she mentions are not Post-Modernists, but really Late-Modernists. Why? Because like ultra- or Neo-Modernists they take Modernist disjunction and abstraction to an extreme. Essentially their practice goes against the thirty or so definers of Post-Modernism I have mentioned – all those connected with semantics, convention, historical memory, metaphor, symbolism and respect for existing cultures. Their work is much closer to Agonistic Modernism, except it is more extreme, exaggerated – in short, 'Late'.

Indeed this brings us to the essential definition of Late-Modernism: *in architecture it is pragmatic and technocratic in its social ideology and from about 1960 takes many of the stylistic ideas and values of Modernism to an extreme in order to resuscitate a dull (or clichéd) language.*[32] Late-Modern art is also singly coded in this way and like the Modernism of Clement Greenberg tends to be self-referential and involved with its art-specific language, even minimalist in this concentration as so many critics such as Umberto Eco have pointed out.[33]

* * *

IV Schismatic Post-Modernism is Late-Modernism

What I am suggesting here is not a minor shift in nomenclature, but a complete reshuffling of categories: that is to redefine as mostly 'Late' what Davis, Goldberger, Foster, Jameson, Lyotard, Baudrillard, Krauss, Hassan and so many others *often* define as 'Post'. It is mostly 'Late' because it is still committed to the tradition of the new and does not have a complex

31 *op. cit.,* p. 39.

32 The essential definitions of Modern, Late- and Post-Modern were initially proposed by me in *AD News* 7/81, also published later in 'Post-Modern Architecture: The True Inheritor of Modernism', *Transactions 3,* RIBA, London 1983, pp. 37-40.

33 *op. cit.,* note 9, pp. 66-7.

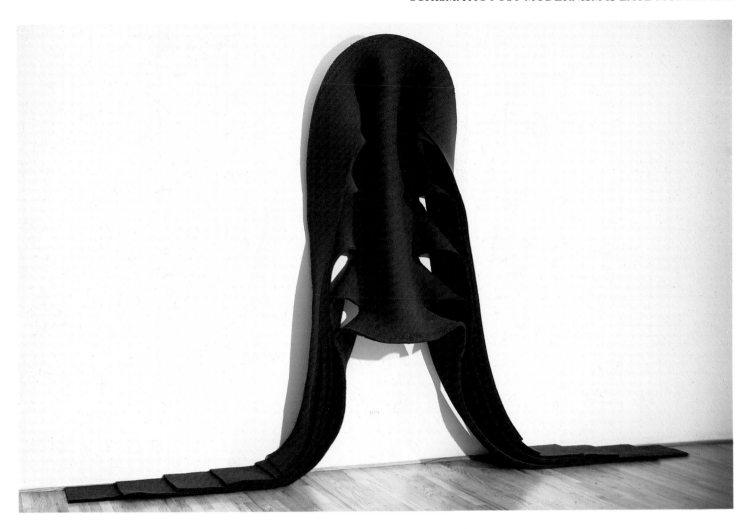

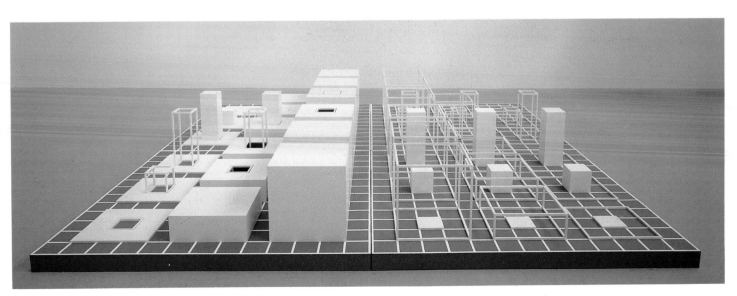

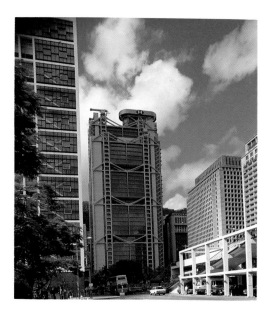

[29] Norman Foster and Foster Associates, Hongkong Shanghai Bank, Hong Kong, 1982-6. By adhering to local convention and breaking up the volume into slim towers, Foster has ironically fit into a Hong Kong that no longer surrounds this building. Judged as a Post-Modern work, the architecture fails to relate to either the tastes and conventions of the Chinese or the functions and styles of the bankers (although of course the elegant, steely-grey muscle is a calculated metaphor). But judged as the handmade Rolls Royce of Late-Modernism the building is indeed the triumph that the architectural profession has waited so long for: it is totally 'built' all the way through with every joint, balustrade and desk turned into a work of art – the apotheosis of Arts and Crafts philosophy. (Photo C. Jencks)

[30] Banking Hall. The 'Cathedral of Commerce', the metaphor of the 1920s skyscraper, is revived in this giant nave that pushes up nine storeys and then off to the right to catch some reflected light. Note the way trusses and columns break through the window walls expressing their Arts and Crafts 'honesty' (upper right and bottom); an interesting symbol of Modernist candour. On many levels this building is rigorously straightforward and thus quite awkward; truth is not always beauty. Whether or not it works well in a functional sense is a question for a future study. Surely it is well adapted for technological change and, in a sense, the culmination of sixty years of Modernist ideology. (Photo Ian Lambot)

relation to the past, or pluralism, or the transformation of western culture – a concern with meaning, continuity and symbolism. I don't for a moment believe that these writers will agree with me, but I do believe that what is at stake is more than a pedantic distinction. It is a difference of values and philosophy. To call a Late-Modernist a Post-Modernist is tantamount to calling a Protestant a Catholic because they both practise a Christian religion. Or it is to criticise a donkey for being a bad sort of horse. Such category mistakes lead to misreadings, and this may be very fruitful and creative – the Russians read Don Quixote as a tragedy – but it is ultimately violent and barren.

Try to read Norman Foster's recently completed Hongkong Shanghai [Bank as a Post-Modern building and you will get as far as the 'non-door' where the two escalators are shifted at an angle to accommodate the Chinese principle of *Feng Shui*. Is it contextual or related to the buildings surrounding it and the vernaculars of Hong Kong and China? Only in the most oblique sense that it is 'high-tech' and one side has a thin, picturesque group of towers. Is it involved with the 'taste-cultures' of the inhabitants and users? Only in the subliminal sense that its 'skin and bones' suggest muscle power. According to the permissive definitions of 'Nothing Post-Modernism' it should be a member of this class, because it is a 'rupture' with Modernism and fully committed to the tradition of the new. Indeed most of [its parts, adopted from aeroplane and ship technology, were purpose-built in different parts of the globe precisely to be new. It is the first radical 'multinational' building – parts were fabricated in Britain, Japan, Austria, Italy and America – resolved by all the technologies of the post-industrial society, including of course the computer and instant world communication, and therefore according to the definitions of J.F. Lyotard and others it should be a prime example of Post-Modernism. But it isn't, and if it were it would be a failure.

No, it has to be judged as the latest triumph of Late-Modernism and celebrated for what it intends to be, namely, the most powerful expression of structural trusses, lightweight technology, and huge open space stacked internally in the air. The cost of the building – and it is called the most expensive building in the world – directly reflects these intentions, for it turns out that the money went on the bridge-like structure and the superb use of finishing materials, surprising areas to take up so much of a budget. Thus, I don't mean only to criticise the building for its Post-Modern shortcomings, but to support it for its Late-Modern virtues. These are, as usual, the imaginative and consistent use of the technical language of architecture. The morality of Late-Modernism consists in this integrity of invention and usage; like Clement Greenberg's defence of Modernist morality the work has to be judged as a hermetic, internally related world where the meanings are self-referential. Literally, does the high-tech fit together and work, visually, poetically and functionally? The answers to all these questions appear to be positive, although it is too soon to be sure.

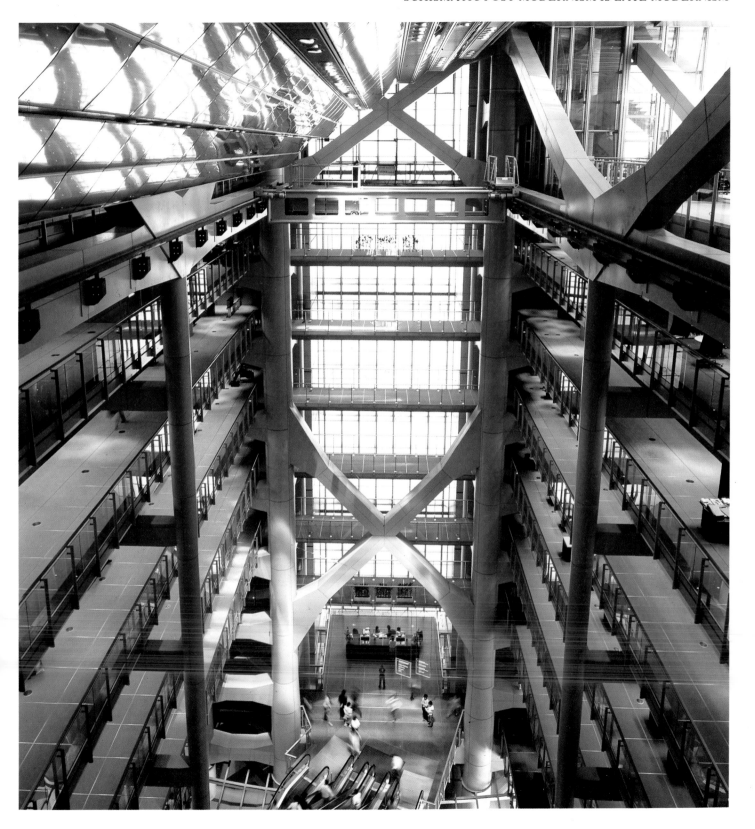

[31] Bernard Tschumi, Parc de la Villette, 1984 –. One of the first 'red points' in Tschumi's abstract grid is this *'folie'* in the Late-Constructivist Style. The revival of twenties Modernism, in an extreme form, is often mistaken for Post-Modernism. (C. Jencks)

[32] Post-Modern Classical Art, 1960-80, the five main traditions. Again, as with architecture, there is a common approach which shows differences of focus. Some artists also tend to work concurrently within several traditions.

34 Jean-François Lyotard, *The Postmodern Condition: A Report on Knowledge*, Manchester University Press, 1984, pp. XXIII, XXIV and 3. The book was first published in French in 1979.

35 *ibid.*, pp. XXV and 82.

36 *ibid.*, p. 79.

The concept of Post-Modernism is often confused with Late-Modernism because they both spring from a post-industrial society. Of course there is a connection between these two 'posts', but not the simple and direct one that the philosopher Jean-François Lyotard implies. He opens his book *The Postmodern Condition: A Report on Knowledge* with the elision of the two terms: 'The object of this study is the condition of knowledge in the most highly developed societies. I have decided to use the word postmodern to describe that condition . . . I define *postmodern* as incredulity toward metanarratives . . . Our working hypothesis is that the status of knowledge is altered as societies enter what is known as the post industrial age and cultures enter what is known as the postmodern age.'[34]

Lyotard's study is mostly concerned with knowledge in our scientific age, in particular the way it is legitimised through the 'grand narratives' such as the liberation of humanity, progress, the emancipation of the proletariat, and increased power. These 'master narratives', he contends, have gone the way of previous ones such as religion, the nation-state and the belief in the destiny of the west; they've become non-credible and incredible. Indeed all beliefs, or master narratives, become impossible in a scientific age, especially the role and ultimate legitimacy of science itself. Hence the nihilism, anarchism and pluralism of 'language games' which fight each other, hence his belief that Post-Modern culture entails a 'sensitivity to differences' and a 'war on totality.'[35] Post-Modern is then defined as 'a period of slackening', a period in which everything is 'delegitimised'. Given this nihilism and the sociological jargon, one can understand why our Sunday reporter at *Le Monde* was so upset by the spectre about to descend, like a fog of waffle, onto the breakfast table. Lyotard has almost defined Post-Modernism as this 'slackening' relativity. But in another section he amazingly defines the 'postmodern' as pre-Modern: 'What space does Cézanne challenge? The Impressionists. What object do Picasso and Braque attack? Cézanne's . . . A work can become modern only if it is first postmodern. Postmodernism thus understood is not modernism at its end but in the nascent state, and this state is constant.'[36]

This crazy idea at least has the virtue of being original and it has led to Lyotard's belief in continual experiment, the agonism of the perpetual avant-garde and continual revolution. This also led to his exhibition of experiments with the media at the Pompidou Centre called *Les Immatériaux* which, from reports, appears to have been mis-labelled Post-Modernist. I'm not sure, since I haven't seen the exhibition, but it is clear that Lyotard continues in his writing to confuse Post-Modernism with the latest avant-gardism, that is Late-Modernism. It's embarrassing that Post-Modernism's first philosopher should be so fundamentally wrong.

However it is not surprising, because the 'mistake' has such a long pedigree, pre-dating Ihab Hassan's work, on which Lyotard rests for so much of his cultural evidence. Thus we are at a 'crisis' point – to use one of his concepts of legitimation – over whether to go on using the word Post-Modern to encompass two opposite meanings and diverging tradi-

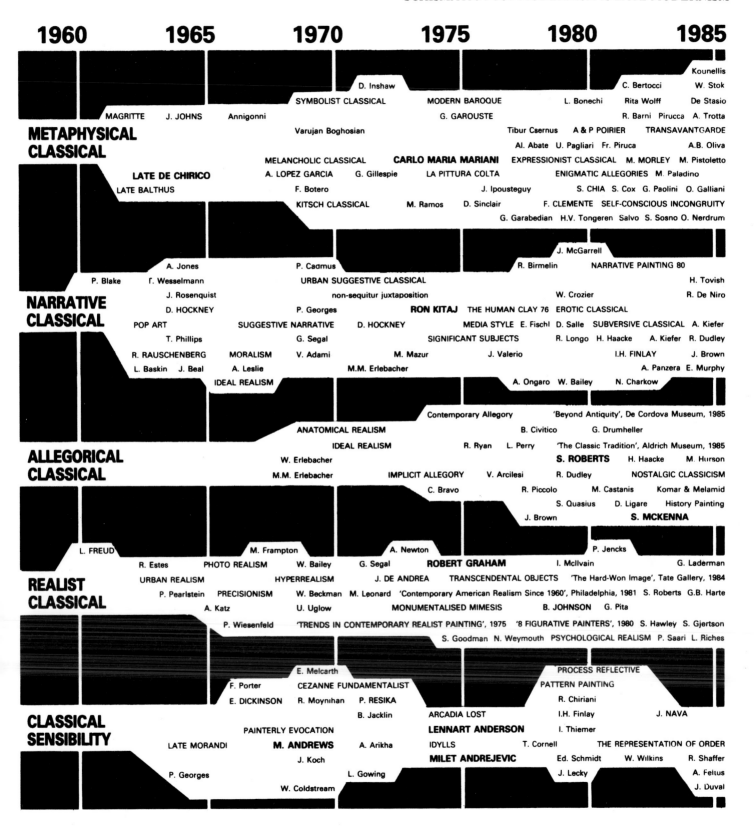

[33] David Salle, *The Cruelty of the Father*, 1983, acrylic and chair on canvas, 98 x 197in. Images from the mass-media and 'How to Draw' manuals blend with abstraction and a map outline within this diptych. Salle often juxtaposes Modernist and Classicist genres while letting the viewer supply the unifying interpretation. (Courtesy of Mary Boone Gallery, New York)

[34] Robert Longo, *Master Jazz*, 1982-3, mixed media, 96 x 225 x 12in. Executives fighting and frowning in a supercool environment are set against stereotypes of suffering and pleasure which, like those of Salle, are lifted from the media and presented with detached professionalism. Tough, descriptive realism relates to Early Modernism while the implied allegory tends towards the Post-Modern. (Courtesy of Metro Pictures, New York)

tions. It is literally nonsense to continue with this linguistic confusion. Furthermore, I would argue that the meanings and definitions I have proposed – dichotomising Late- and Post-Modern – gain in power precisely to the extent that they are used together, because they elucidate opposite intentions, traditions of art and architecture which are fundamentally opposed to each other. Lyotard, because he is a philosopher and sociologist of knowledge and not a historian or critic of these cultural trends, is not finely tuned to their differences.

Having stated this case for a fundamental distinction between Post- and Late-Modernism, one should, however, add some refinements which modify an absolute difference. Both traditions start about 1960, both react to the wane of Modernism and some artists and architects – for instance David Salle, Robert Longo, Mario Botta, Helmut Jahn, and Philip Johnson – either vacillate between or unite the two. This overlap, or existential mixing of categories, is what we would expect in any period after the Renaissance when, for instance, an artist such as Michelangelo could move from Early Renaissance to Mannerist and Baroque solutions of sculptural and architectural problems. So there are indeed many artists whom Hal Foster *et. al.* include in their corpus as 'postmodernists of resistance' that should also be included as Post-Modernists: Robert Rauschenberg, Laurie Anderson, some feminist art which uses conventional subject matter in an ironic way, Hans Haacke and others who might be termed 'Agonistic' or combatative. But they should be so classified only in so far as their intention was to communicate with society and its professional elites through the use of double coding, and even if such artists are termed Post-Modern, it wouldn't guarantee their value which much depend, as always, on the imaginative transformation of a shared symbolic system. The role of the critic must first be to define the field – that is the very real traditions which are evolving – and then make distinctions of quality and value, a process I have started with an evolutionary tree showing the five main Post-Modern Classical strands of art: the Metaphysical, Narrative, Allegorical and Realist Classicists and those who share a classical sensibility. We can see in this return to the larger western tradition a slow movement of our culture, now worldwide, back to a 'centre which could not hold' (to misquote Yeats). The return has various causes, but among the most important is the idea that the value of any work must depend partly on tradition, both for its placement and quality. The tradition of the new made such a fetish of discontinuity that now a radical work of quality is likely to have a shock of the old.

[35] Venice Biennale, *Strada Novissima*, 1980, [visible façades are by Venturi, Rauch and Scott Brown and Leon Krier. The *Strada* illustrates the 'return to architecture', to polychromy, ornament and above all to the notion of the street as an urban type. (Photo C. Jencks)

① *Futurists? or Dada?*

37 Friedrich Nietzsche, *Thus Spake Zarathustra*, 1883, pp. 108 and 162, quoted from Will Durant, *The Story of Philosophy*, Washington Square Press, New York 1981, p. 417.

38 Le Corbusier, *Towards a New Architecture*, The Architectural Press, London 1927, p. 12.

V The Counter-Reformation in Architecture

The Heroic period of Modernism during the 1920s was not just confined to architecture but extended across the avant-garde in many arts. For a short time T.S. Eliot and Ezra Pound in literature, Stravinsky in music, Eisenstein in film, Brancusi in sculpture and Leger and Picasso in painting shared an implicit reformist role of shaping a new sensibility. The avant-garde and the intellectual elite defined a common role, that of being the leaders of a new mass-culture. This ideal of a new leadership resulted partly from the breakup caused as much by the First World War and the Russian Revolution as the industrial revolution. But its deeper roots went back to the nineteenth century and to the radical effects science, Darwinism and secularisation had on Christian culture. The post-Christian ideology, first proclaimed by Nietzsche as the philosophy of superman, was aimed directly at a creative elite and it is not surprising that the young Le Corbusier and Walter Gropius were brought up, as were so many artists of the early 1900s, on Zarathustra's oracular pronouncements: 'He who must be a creator in good and evil – verily, he must first be a destroyer, and break values into pieces . . . And whatever will break our truths, let it break! Many a house hath yet to be built. [It's clear why this appealed to architects.] Dead are all Gods; now we will that superman live . . . I teach you superman. Man is something that shall be surpassed. What have ye done to surpass him? . . .'[37]

The avant-garde took on this Darwinian role to 'transvalue all values' and Le Corbusier, reading these passages, even adopted the biblical intonation of his mentor. If one reads art and architecture manifestoes of the 1920s, from Berlin to Moscow to Paris, they all sound like this scripture but sent by telegram. And their evangelical style is basically Nietzsche's. Le Corbusier: 'A great epoch has begun. There exists a new spirit. Industry, overwhelming us like a flood which rolls on towards its destined ends, has furnished us with new tools adapted to this new epoch, animated by a new spirit. Economic law inevitably governs our acts and our thoughts . . . We must create the mass-production spirit. The spirit of constructing mass-production houses. The spirit of living in mass-production houses . . .'[38]

The rhetoric of a spiritual rebirth as proclaimed in New Testaments of the Machine Aesthetic finally drove out the Beaux-Arts evil and was enshrined in the Weissenhof Settlement, Stuttgart, in 1927. The white, Protestant Reformist style was built there by the major architects from Europe and the impressive thing was not so much the quality of the buildings as the fact that the leaders had all practised versions of the same doctrine, a dogma that excluded convention, traditional craftsmanship and almost every quality that western architecture had enshrined except constructional beauty and dynamic space. Traditional aesthetics and urbanism were put on the Calvinist Index.

Fifty-three years later in the old Arsenale in Venice all this transvalua-

tion was itself transvalued. Paolo Portoghesi and other critics and architects, including myself, organised the new Biennale of Architecture around the theme 'The Presence of the Past.' Back were ornament, symbolism and the other taboos. The *Strada Novissima*, based on a Renaissance stage-set, consisted of twenty facades designed by leading Post-Modern architects. Most of them were in a Free-Style Classicism, a style which used the full repertoire of mouldings, keystones and columnar orders, but usually in an ironic fashion again indicating their place in history after Modernism, acknowledging that the return to tradition had to be based on current social and technical realities. Since then the most challenging Post-Modern Classicism has grown in strength to be practised around the world – even by the Indians and Japanese – using materials such as prefabricated concrete and aluminium.

This Counter-Reformation has had its new saints and zealous bishops who have not failed to establish a renewed orthodoxy. Aldo Rossi, the new Italian pope of architecture, has issued decrees on Neo-Rationalism and the importance of memory for rebuilding the city (destroyed by Modernism). The idea of autonomous architecture – an architecture responding to its own typological laws of streets, squares and city blocks – has returned. The monument, which Modernists had declared forbidden goods, has been quickly reinstated in encyclical after encyclical. The most militant apostle, a veritable Ignatius Loyola, Leon Krier, has established his own following called Rational Architects, equivalent to the Society of Jesus. And these New Jesuits from Spain, Italy, Belgium and France have even insisted on building with ancient techniques of craftsmanship and stone. An indication of how powerful St Ignatius Krier has become, even without building a single structure, is that he was given a grand exhibition of his drawings in the High Church of Modernism, the Museum of Modern Art, in the summer of 1985.

The new doctrines spread very quickly with exhibitions in Helsinki, Chicago and Tokyo. A northern Vatican was established in Frankfurt where Heinrich Klotz made a thorough collection of Post-Modern documents – drawings and models – in a building which could be called the first museum of Post-Modern architecture (especially designed by Matthias Ungers). If the 1927 Weissenhof exhibition represented the triumph of Protestantism, then the 1980 Venice Biennale and its subsequent re-erections in Paris and San Francisco represent the triumph of the Counter-Reformation, its many Councils of Trent.

This metaphor, or mythology, of recent architecture is getting rather heavy but before I drop it a last parallel should be mentioned. The real Counter-Reformation resulted in the Baroque style (then called the Jesuit Style) and the building of many splendid churches replete with exuberant polychromy and narrative sculpture. All of this was a sign of a new spirituality and the new authority of the Church. While the stylistic parallel of the Counter-Reformation with Post-Modernism can be made – and there is even a new Baroque – there is no new religion and faith to give it

[36] Arata Isozaki, Tsukuba Civic Centre, Japan, 1980-3. Ledoux and Michelangelo, among others, are absorbed in Free-Style Classicism and rendered in High-Tech. The Japanese have always appropriated foreign influences and synthesised them for their own ends and styles. (Photo Satoru Mishima)

substance. In place of this are several substitutes which form the agenda of Post-Modernism. The atheist art critic Peter Fuller, in his book *Images of God: The Consolation of Lost Illusions*, 1985, calls for the equivalent of a new spirituality based on an 'imaginative, yet secular, response to nature herself'.[39] His Post-Modernism, like my own, seeks 'a shared symbolic order of the kind that a religion provides', but without the religion. How this is to be achieved, he doesn't spell out any more than I do in four books on the subject.[40] But the examples from the past are objective standards against which we can measure Post-Modernism; artistic traditions may be more widely defined than scientific ones but distinctions of value can still be defined objectively.[41] Right-wing critics such as Roger Scruton, left-wing critics such as Fuller, and liberals such as Ernst Gombrich, agree on this and on condemning the relativism that Lyotard's position entails.[42] In both art and architecture the tradition of Post-Modernism is beginning to mature and we can see limited progress and development akin to that of the Renaissance.

* * *

VI The Post-Modern Information World and the Rise of the Cognitariat

Post-Modernism as a cultural phenomenon is often hard to grasp because it is so various in style and discontinuous, even within a single building or work of art. Eclecticism is the natural style for cultural diversity and there is one fundamental reason for the increasing pluralism of our era: it has been united by current technologies into an instantaneous, twenty-four-hour 'information world', the Post-Industrial successor to a Modern world based on industry. To understand this new situation is to grasp a series of contrasts and not a single entity, or predetermined process. The shifts are kaleidoscopic and simultaneous – that from mass-production to segmented production; from a relatively integrated mass-culture to many fragmented taste cultures; from centralised control in government and business to peripheral decision-making; from repetitive manufacture of identical objects to the fast-changing manufacture of varying objects; from few styles to many genres; from national to global consciousness and, at the same time, local identification – and there are many more related changes than this short list implies. Fundamentally we are passing into a new era of culture and social organisation, what Daniel Bell called the Post-Industrial Society in 1967, and what others have called the 'Third Wave', or 'information society'.[43] Several related events have brought it into existence.

In 1956 for the first time in the USA the number of white collar workers outnumbered blue collar workers, and by the late 1970s America had made

[37] O.M. Ungers, German Architectural Museum, Frankfurt, 1982-4. A white, gridded abstraction, reminiscent of Sol LeWitt and Peter Eisenman, has thematic elements – a house within a house – which, along with the collection of drawings, plans and models built up by Heinrich Klotz, establish it as *the* Museum of Post-Modern architecture. (Photo C. Jencks)

39 Peter Fuller, *Images of God: The Consolation of Lost Illusions*, Chatto and Windus, London 1985, p. XIII.

40 The notion that Post-Modernists must attempt to develop a 'shared symbolic order' is a fundamental idea put forward in the books cited in note 10, as well as my *Post-Modern Classicism*, *Architectural Design* 5/6, 1980, and *Towards a Symbolic Architecture*, Academy Editions, London/Rizzoli, New York 1985.

41 This idea has been reiterated by E.H. Gombrich, among others; see his 'The Tradition of General Knowledge' and 'Art History and the Social Sciences' papers published in *Ideals and Idols*, Phaidon, London 1979, especially pp. 21-3 and 143-66.

42 *ibid.*, see also Peter Fuller's review 'Roger Scruton and Right Thinking', *op. cit.*, pp. 36-42.

43 Daniel Bell, 'Notes on the Post Industrial Society' (I & II), *The Public Interest*, Spring 1967; Alvin Toffler, *The Third Wave*, William Collins & Sons, London 1980; John Naisbitt, *Megatrends*, Ten New Directions Transforming Our Lives, Warner Books, New York 1982, pp. 1-39.

NEW
YORK

October

↓

TOKYO
October

↓

HONG
KONG
October

↓

SINGAPORE
October

↓

FRANKFURT
October

↓

PARIS
October

↓

LONDON
October

[38] *The World Village, October 19, 1987.* Instant global communication, electronic dealing systems, automated buying and selling programmes together exaggerate the market activity as the Post-Modern world immediately responds to the flow of information.

[39] Mimmo Paladino, *Cordoba*, 1984, oil on canvas, 118⅛ x 157½ in. Every year Paladino returns home from the rigours of the international art scene and goes back to his roots in Southern Italy to find 'mythic inspiration' in the old cults that have flourished there for two thousand years. A suggested narrative is compounded from Egyptian, African, and European sources. (Waddington Galleries, London)

[40] Lorenzo Bonechi, *Visitation*, 1985. Whispy, mannerist figures inhabit a stripped-down Italian Renaissance landscape, an attempt to generalise the Christian convention on a timeless scale. (Fabian Carlsson Gallery, London)

the shift to an information society with relatively few people – 13 percent – involved in the manufacture of goods. Most workers – 60 percent – were engaged in what could be termed the manufacture of information. Whereas a Modern, industrialised, society depended on the mass-production of objects in a factory, the Post-Modern society, to exaggerate the contrast, depends on the segmented production of ideas and images in an office. Very little of the population today are farmers – in the Modern world of 1900 they constituted 30 percent of the labour force, in the Post-Modern world only 3 percent. The service sector has held steady over the last ten years at 11 to 12 percent of the total workforce, about the same percentage as unemployment. In a Post-Modern world, the fundamental social fact is the revolutionary growth of those who create and pass on information; or put another way, the sudden emergence of what looks like a new class, the replacement of the proletariat by the cognitariat. But of course these new workers are not working class, nor exactly middle class, but rather para-class. Statistically most of them are clerks, secretaries, insurance people, stockbrokers, teachers, managers, governmental bureaucrats, lawyers, writers, bankers, technicians, programmers and accountants. Their salaries differ as much as their way of life and status, and supposing one could subdivide this large group into layers, finely graded from cognicrats at the top to cogniproles at the bottom, distinctions would be largely specious because the internal divisions are always changing relative to each other, as there is a constant change of jobs and their specifications. Individuals move within the overall group. It makes more sense to contrast this para-class with previous historic groups in order to understand shifts in power and production.

As important as the information society is the organised network of world communication which allows it to function. This also started, symbolically at least, at the end of the 1950s with the launch of Sputnik. The Columbia Space Shuttle of 1981 brackets the period of history when satellite communication was combined with ubiquitous jet travel, computer processing, the old-fashioned telephone and countless world circulation magazines and newspapers, to form an efficient *network*, a community of world producers and consumers. The significant part is not the invention of this or that technology, but the sudden emergence of an integrated system of global communication which is quick and effective.

On an economic level it gives multinationals much power to move money and products as they please. On a large scale it unites mass-audiences for sporting events and royal weddings and, on a small scale, it puts scientists, artists and individuals with similar interests in touch with each other. One reason there is no longer an artistic avant-garde, in the traditional Modern sense, is that there is no identifiable front line to advance in the world village, no group or movement that cuts across all the arts, no enemy to conquer, no coherent bourgeoisie to fight, no established *salon* to enter. Rather there are countless individuals in Tokyo, New York, Berlin, London, Milan and other world cities all communicating and competing

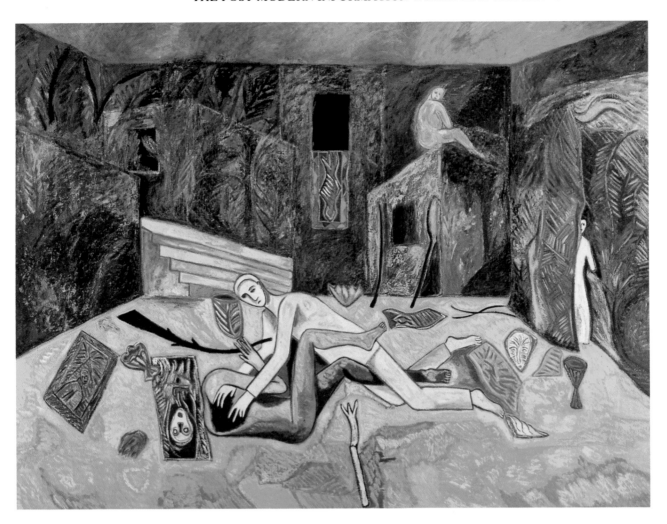

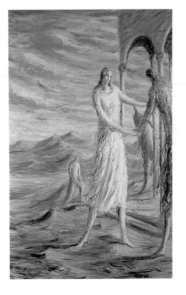

with each other, just as they are in the banking world. As I mentioned above, Italian artists such as Mimmo Paladino who feature their mythical 'roots' are just as likely to work part-time in New York as they are to retreat to the Italian countryside to re-establish their ethnic identity. If the information world has had one obvious effect on culture it is to have put all content in question. The Post-Modern world is the age of quotation marks, the 'so-called' this and 'Neo' that, the self-conscious fabrication, the transformation of the past and recent Modern present, caused by the fact that almost all cultures are now within instant communication with each other. The negative aspects of this are clear enough in the ersatz creations which have spread everywhere – such things as Holiday Inns adopting regional styles – while the positive aspects are evident in the achievements of science during its multinational phase, and in the eclectic work of Post-Modern artists and architects.

To bring out the dramatic change that has occurred in twenty years we might adapt a classification of anthropologists, the division of historical epochs into ages based on their fundamental forms of production. First is the agricultural phase of development, a result of the Neolithic Revolution, roughly 10,000-5,000 BC, when 95 percent of the population were farmers and peasants and many of them were controlled by a priestly class ultimately governed by a king or emperor. In this Pre-Modern era, lasting until the birth of capitalism and the Renaissance, production was at a relatively small scale, and individuals controlled most of the property through an hierarchical society. The 'shape of time', to adopt George Kubler's phrase, was slow-changing, a horizontal line punctuated fairly regularly with repetitive patterns, the cycles of work and the recurrent seasons: one could call it reversible time, since one year was very like another, unless there was war.

With the rise of capitalism in Italy and France and then the industrial revolution in England and the rest of Europe, the Modern world arrived: at least that is the term often given it by historians such as Arnold Toynbee. By the nineteenth century, most of the population was working class, led by a bourgeoisie who commanded most of the means of production. It's an obvious point, but one worth stating, that the Modern world tries to centralise manufacture, control it for mass-production, just as it tries to codify and regularise consumption. Mass-culture is the ultimate product of the Modern world, the factory is its implicit form of organisation, and rationalisation its final value. The shape of time is now more vertical and sequential, it is punctuated by large-scale wars and massive population migrations: reversible time is now replaced by the linear time of history and sequential inventions.

In the Post-Modern world, 1960 onwards, most of the previous relations of production have altered and the whole value system has been distorted. Primary products are no longer such things as automobiles, and the main industries (at least in the 'First World') are no longer interested in heavy equipment and steel production, but rather in information – software as well as computers, such lightweight equipment as that of air and space

	Production	Society	Time	Orientation	Culture
PRE-MODERN 10,000 BC-1450	*Neolithic Revolution* agriculture handwork dispersed	*Tribal/Feudal* Ruling class of Kings, priests & military peasants	Slow-changing reversible	*Local/City* Agrarian	*Aristocratic* integrated style
MODERN 1450-1960	*Industrial Revolution* factory mass-production centralised	*Capitalist* owning class of bourgeoisie workers	Linear	*Nationalist* Rationalisation of business exclusive	*Bourgeois* Mass-culture reigning styles
POST-MODERN 1960-	*Information Revolution* Office segmented-production decentralised	*Global* para-class of cognitariat office workers	fast-changing cyclical	*World/Local* multinational pluralist eclectic inclusive	*Taste-Cultures* many genres

technology, such inventions as those in genetics and above all the gigantic electronics industry, the largest manufacture on the planet. In addition, this information is not 'owned', or at least monopolised, for long. Nor is it consumed by use, or decreased by re-use, as objects tend to be in the capitalist world. Quite the reverse: information tends to multiply itself through use, create ever bigger circles of decision-making. Thus, unlike the previous systems of production, where an aristocracy and bourgeoisie asserted power over a limited resource in order to exploit it effectively, the Post-Modern world is not owned, or run, or led, by any class or group, unless it is the cognitariat. But this one is so big at 60 percent of the workforce, and so fluid, as to be non-existent in terms of a traditional class with vested interests and ideology. The situation is more complex than the customary models with which we have worked – the notions of the two-party system, 'left- and right-wing', capitalist and working class.

The Post-Modern world is making a nonsense of such polarities and there are many Post-Marxists now hard at work trying to reconceptualise the notions of conflict and suffering in an information society. Not surprisingly it turns out that many high-level managers are just as alienated as the rest of the labour force, because they have to process much more information per minute, per day than the exploited wage-slave did one hundred years ago, and they do it for the most abstract client of all, the one most distanced from them, that is the world market. Knowing their profits, it may be hard to feel sorry for them, but alienation is alienation even when it's self-induced and

[41] Three types of society based on their major form of production.

well-paid. The Post-Modern information world has not decreased the amount of work done by the cognitariat, but actually increased the decision-making load, because the launch of any advanced technical product now depends on the organised knowledge of many specialists, a group J.K. Galbraith has called the 'technostructure'. This group includes not only technologists but also a small army of accountants, lawyers and advertisers. If there is any ultimate control in this situation it is not achieved through ownership, but through the ability to manipulate knowledge. This is now where the ultimate power rests – with the cognicrats and their teams of market analysts and experts.

The main shifts from a Pre-Modern to Post-Modern world can be seen [most vividly in a comparative diagram. In the Post-Modern era the shape of time rises steeply towards the vertical as world events effect each other in a chain reaction, as generations seem to come and go much faster than the normal twenty years, as all cultural systems seem to approach the quick-changing evanescence of fashion: in short, as much more information is processed in ever smaller periods of time. Andy Warhol overstressed the speed and democracy which the new media were bringing when he predicted: 'in the future everybody will be world-famous for fifteen minutes'. A generation in the art world, a new 'ism', now lasts at least two years – one for discovery, the next for promotion. Movements and trends are declared 'dead stock' before they can mature. No matter how good or bad artists may be, or how slow or fast they want to develop, they have to acknowledge this world media system and its fashion-go-round, if only to reject it. Indeed a lot of Post-Modern art is directed against the exploitation and manipulation of information, particularly the satirical work of Hans Haacke, or the wry commentary art of Barbara Kruger, and of many artists [who use photography and collage to comment on the media and its values.

The situation may not look promising, but there are positive aspects to it. For one thing there are a good many artists working outside the market nexus who are waiting to be discovered: the pluralism of Post-Modernism is very real, and it hides a great deal of talent. For another thing, as the international art world approaches the conditions of fashion, the shape of time again becomes reversible, but in a new way. One can predict the cyclical transformation of old trends, and a fashionable artist, suddenly rendered obsolete by the two-year swing of taste, can wait until the trend comes round again in a new guise in ten years' time. Development is not impossible under these conditions; it is just made while the artist is both in and out of fashion.

Aside from the basic points made in this diagram there are a series of further shifts produced by the Post-Modern world.

From Mass-Production to Segmented Production
If the Modern world is based on the notion of an endless repetition of a few products, then its successor is based on the idea of short-runs and the targetting of many, different, products. The computerised and totally cyber-

netic production in some industries has partly allowed this situation to develop since it is, in Marshall McLuhan's striking example, just as cheap to manufacture a hundred different tail pipes as a hundred similar ones: the only problem is that individual tastes aren't usually as variable as this potential production. The market for personalised exhaust pipes is limited.

More important than the technologies which allow individualisation are the new alignments in taste, the fragmentation of taste cultures, and the wide array of choices the Post-Modern system promotes. In the United States there were seven hundred radio stations in 1950; now with only a moderate population increase there are more than nine thousand, and many of them are oriented to specific city cultures.[44] ABC, CBS and NBC still control the mass-market, but they are being supplemented by five thousand cable systems, more than one hundred television channels and now, with satellite transmission, the well-equipped consumer can tune into over one hundred different stations. In a city such as Los Angeles one can watch a Spanish or Japanese network, or an all-news programme, a Disney channel geared to family tastes, or one of five movie channels. There is one continuous political programme which shows congressional hearings and such long-running investigations as Irangate, all-day religious stations, and daily slots for education, business, real-estate investment and the arts. Much of this is rubbish, but enough is creative and thoughtful for tastes to be genuinely deepened.

[42] David Salle, *How to Use Words as a Powerful Aphrodisiac*, 1982, oil on canvas, 228 x 449cm. Images from different media are contrasted in an enigmatic allegory. The painter's arm (a clenched fist) confronts some merry-go-round women after Reginald Marsh, who cavort gaily behind a sad African mask, a Picassan image which then leads the eye and mind to a painting which is too short: Abstract Expressionism. Thus the title might really be 'How to Use Images as a Powerful Aphrodisiac' and contrast them, ironically, to be a suppressive. (Galerie Bischofsberger, Zurich)

PRIOR DESIGN - 1985

NEW DESIGN - 1987

EXISTING
BUILDING - 1966

[43] Michael Graves, *Whitney Museum Additions*, 1985 and 1987. Reduced in bulk, the second scheme manages to actually get in more usable gallery space than the first. Both schemes are extremely 'contextual', especially when compared with Breuer's 1966 intervention on the street of brownstones. Now they have mostly gone and so Graves has the difficult and ironic task of having to mediate between high-rise and low-rise, Modern and traditional, sculptural expressionism and reticence. The solution, however, was wrongly interpreted as a Post-Modern put-down of Breuer's building and Modernists leapt to the attack.

43 Daniel Bell, 'Notes on the Post Industrial Society' (I & II), *The Public Interest*, Spring 1967; Alvin Toffler, *The Third Wave*, William Collins & Sons, London 1980; John Naisbitt, *Megatrends*, Ten New Directions Transforming Our Lives, Warner Books, New York 1982, pp. 1-39.

Once again it isn't a single technology or industry that has made the difference, but the combination of several new systems; not cable and satellite television alone, but these combined with the growth of speciality magazines (*Runners World* is the archetype), the recent introduction of specialised sections in large newspapers and the growing diversity of software programmes. As the world shrinks to a village and each new airport becomes more predictable than the last, every culture, as if to compensate for the homogenisation, fragments along new lines of age, sex, place and shared interest. This segmentation of tastes leads to another obvious shift.

From Centralised Authority to Decentralised Pluralism

Those who have written on Post-Modernism have noted the 'loss of authority' which seems so characteristic of our age. The credibility of politicians is as threatened as that of professional leaders and elites. As we have seen, Jean-François Lyotard traces this to the decline in belief systems and the rise of scepticism. No doubt an era of science has cast every ideology into doubt, and there is great uncertainty in the areas that formerly provided security: the role of marriage and the family in a time when many women work and almost as high a percentage are divorced, the place of nations in a world economy dominated by multinationals on one side, and city and regional life on the other. One could go on; there's enough statistical change in all the traditional areas of value to fill several sermons with comment and advice. But the most encompassing trend, it seems to me, is not so much away from belief as towards an increasing plurality of beliefs. Never has consensus been so hard to achieve on a political and professional level. In the architectural world, for instance, there has never been so much conflict, such professional bitterness and hostility. And yet this friction, the debates between Modernists, Late-Modernists and Post-Modernists, or all of them against Traditionalists, or some of them against Free-Style Classicists – all this acrimony doesn't speak of a decline in belief, but of something quite different; a new-found discovery that differences matter, that distinctions can be fought over.

On a geographic level there is a new regionalism, both political and cultural, that is dividing up countries along the cardinal points and climatic oppositions. There is a growing polarisation: between the north and south in Britain; or in America between the East Coast and West Coast, New England and the Pacific Rim. In the art world there is also a widening pluralism with the hegemony of New York challenged by London and Los Angeles as well as city-based groups and dealers in Italy and Germany. Consensus architecture is as unfashionable as consensus politics and single-issue professionals and interest groups dominate both fields. This undermines centralised authority and in architecture can lead to a kind of building stalemate and to 're-re-design': witness London's National Gallery extension or New York's Whitney Museum, where the combination of outspoken criticism, the lobbying of interest groups and the presence of

[4

[44] Nigel Coates and Natø, *Caffe Bongo*, Tokyo, 1987. Post-Holocaust design either celebrates the warped destruction of high-tech in a baroque frenzy, or plays it very sombre and cool. Nineteenth-century cast-iron Doric members are bent by the force of a jet crash ('Bongo') while a Neo-Expressionist painting of The Final Moment hovers overhead. All of this hard-edge angst apparently whets the appetite because it's become the restaurant formula in Los Angeles, Tokyo and New York. (Edward Valentine Hames)

specialised review boards can hold up 're-re-design' for six years – hold it up before it is even officially presented!

The change from the Modern to the Post-Modern world is nowhere more ironically vivid than here. Significantly, Marcel Breuer could design his Late-Modern museum for the Whitney in 1966 with little critical awareness of its appalling relation to the neighbourhood, surrounding brownstone houses or street scale. In fact his work, in present-day terms, was the ultimate form of contempt for the existing context, and it sparked off subsequent urban laws and guidelines which necessitate just the kind of sensitivity he failed to show. Thus it is superbly ironic that these new canons are invoked against Michael Graves' extension of Breuer's building, because Graves has so carefully conceived his designs in the context of what has gone before. Indeed if his proposal has an obvious visual fault it is that of being more contextual than it is original. So, in effect, Post-Modernists have opened the door of pluralism and a lot of Still-Modernists have run through it (along with many other taste cultures) only to try to slam it shut against the doormen.

Ours is an age which will make the nineteenth century look intolerant by comparison. Where there were four or five competing modes locked into the 'Battle of the Styles' in the 1850s to 1870s, there are now ten or more distinct options. Where you could be a Goth or Classicist, or perhaps belong to the middle Alliance Party of its time – the Queen Anne Revivalists – you can now be a Rationalist, or Romantic Pragmatist, practise High-Tech or Free-Style Classicism, belong to the 'High Church of Real Architecture' (Revivalist Classicism) or pull all of it to pieces in the Deconstructionist School. You can be a Derridean Architect, an Organicist, Historicist, Contextualist, Regionalist, or if bored with the 'ists', practise Post-Holocaust Design on expensive restaurants in Tokyo and Los Angeles. A glance at the Post-Modern options shown in the evolutionary tree reveals that you can be almost any architect you care to be today, if you find a client and planning board who are willing.

It's true that most of these approaches can be grouped loosely under either the Late- or Post-Modern umbrellas, but their proliferation does show the basic shift towards pluralism. It is, once again, increased by an information society and there is no reason, short of patience and money, why pluralism and its attendant conflict won't increase even more. Compare the situation with the ideologically neutral automobile industry. There is the same extraordinary proliferation of choice: in America in the Modern era, it used to be either a Ford or Chevy, black or white. Now you can choose from over seven hundred and fifty different models of cars and trucks, and a large, annually changing, number of colours. In the art and architectural worlds the choice of a mode is not as great and the meaning of choice for an artist o architect is completely different, but a similar pluralism has meant that the role of style has shifted from what it was both in the nineteenth century and within Modernism.

From few styles to many genres

The nineteenth century turned the choice of style into a matter of ideology, morality, party politics and the *Zeitgeist*. Either you were for the Gothic Revival, or a hopeless pagan; in favour of progressive engineering, or a reactionary; a well-heeled classicist, or an illiterate eclectic. Fashion, moral arguments and the mental habits of a Modernist era all conspired to force you into one camp or another, and if you were idiosyncratic enough to admit scepticism and a plurality of tastes, you did best to keep it private. Today people are not noticably more tolerant, but they do keep changing their tastes, and at such speed, that their successive dogmatisms look particularly silly. Furthermore, with the global village and the revival of so

[45] Stone Roberts, *The Conversation*, 1985, oil on canvas, 72 x 90 in. A nineteenth-century conversation piece becomes the genre for this twentieth-century domestic scene: afternoon tea, guests leaving or arriving, children stealing apples or reading books and in the background the menacing city. The central couple are engaged in an enigmatic and suggestive discourse – an allegory without a plot. (Robert Schoelkopf Gallery, New York)

[46] Charles Vandenhove, *Place de Tikal, Hors-Château*, Liège, 1978–. Part restoration, reproduction and sympathetic invention, this *place* weaves together new concrete technology and the traditional scale of European building. Vandenhove, in all his work, combines opposites and carries forward the spirit, not letter, of tradition. Sculpture by the Poiriers and others is as much a part of this language as the several precast 'Liège Orders'. (Charles Vandenhove)

many competing 'Neo-Styles', the moral claims of each look more and more like wishful thinking. We have reached a paradoxical point with the breakdown of consensus, with the end of national styles or Modernist ideology, where almost any style can be, and is, revived. The noted art historian Heinrich Wölfflin once claimed that in any period 'not everything is possible'. As a logical truth this statement is unimpeachable, but it's of little use today with our *embarras de richesses*. We need rules of discrimination to choose among the ten or so reigning styles, rules of professional etiquette to deal with the increasing architectural disputes, rules of social conflict to handle the rising competition between minorities in an age when everyone is fast becoming a member of a new minority.

Mild paranoia is a characteristic Post-Modern feeling, a consequence of superabundant choice and widespread pluralism. With no recognised authority and centre of power many professional groups (and even whole countries) feel victimised by a world culture and marketplace that jumps, sporadically, in different directions. Now the so-called superpowers, Russia and America, are seen to be economically and politically weak on a global scale; their efforts are thwarted not only in their sphere of influence when a smaller country challenges them, but also in the world economic system in which they play a minority role. Even recent economic successes such as Japan, South Korea and Singapore, or the Arab countries, have to bow to the global network. The Post-Modern information world has made everyone realise, sometimes twenty-four hours-a-day when their currency is falling in value, that they are part of a shrinking minority, and getting smaller all the time, as the world marketplace becomes bigger and more integrated.

In the arts, stylistic pluralism and historical revivalism have created a new situation more like the pre-industrial past than the Modernist period. Instead of believing in one or a few styles, or a progressive style in architecture, the options force us to reassert a freedom of choice and comparative judgement. One chooses 'the right style for the job' in architecture, or the [4 suitable genre for the subject in painting. We may have given up the idea of an hierarchy of genres – history painting at the top, or churches and city halls as the most important building types – but the basic notion of a gamut of oppositions has replaced the idea of 'the one true style'. Variety of mood and suitability of choice are the new values which replace stylistic orthodoxy and consistency.

If 'Modern Masters' are invoked for the pluralism of choice they offered, they are Picasso and Duchamp, Stravinsky and Le Corbusier. These Modernists went through four or five stylistic periods (unfortunately, from our point of view, one by one). If previous periods are studied for their attitudes and skills they are eclectic ones, where artistic freedom was at a premium and dogmatism was under control. To 'eclect' means 'to choose', 'to pick out' among many alternatives the best selection, and to combine it with other chosen alternatives. Obviously in an eclectic building or painting some sort of totality must finally result, or the amalgamation degenerates

into whimsy and private language games. There are rules of combination and choice for the eclectic as much as for his opposite, the purist, and in both cases they concern the connections between the parts and the relevance of the parts chosen to the meaning of the whole.

From consistent to kaleidoscopic sensibility

The fundamental shift in mood that the Post-Modern world has brought is a new taste for variety, even incongruity and paradox. This taste has grown naturally out of the Modern world celebrated by Baudelaire in the strange dynamic life of the Parisian streets, and inevitably it has developed as an addition to the Modern poetics of collage and disjunction, of Cubist assemblage and Joycean stream-of-consciousness. As Marshall McLuhan pointed out in the 1960s, nothing is so bizarre as the juxtapositions that occur everyday on the front page of a good newspaper, and the Post-Modern sensibility has been subjected to even greater incongruity by television. Any good news-stand carries such a profusion of specialist magazines proclaiming opposite virtues that an urbanite naturally develops a taste for heterogeneity. Of course many individuals would prefer to limit themselves to a few tastes and develop discrimination within a narrow band, and these loyalties are indeed what makes the overall pluralism work coherently. But if everybody is limited to a few minority taste cultures, there is still a residual taste for pluralism itself, and for the juxtapositions it entails.

One of the popular films that exploited this incongruity was *The Gods Must Be Crazy* which tells the stories, in parallel juxtaposition, of a Kalahari bushman, a Marxist guerrilla à la Castro, a love-sick backwoodsman, and a pretty city teacher lost in the out-back; and it manages to interweave these discontinuous worlds into a lyrical whole. Federico Fellini often turns the mad competition of many opposite tastes into a melancholic spectacle of hilarious sadness and nearly every one of his movies has such a scene – a Post-Modern carnival. This kaleidoscope of pluralism is not to everyone's taste and it can be tiresome. But it is a fact of life in the global village, and many artists such as Ron Kitaj, or architects such as James Stirling, will incorporate incongruous matter into their work because this disjunctive variety appeals to their sense of reality. If the culture is heterodox, then the best artists will deal with this truth.

From Exclusion to Inclusion

Perhaps the biggest shift in the Post-Modern world is the new attitude of openness. It's not just a taste for heterogeneity which has brought this about, but also a new assertion of minority rights, of 'otherness'. The women's movement is characteristic of many Post-Modern movements that were taken up in the 1960s, to become a recognised political force in the 1970s. But no single movement is typical of this widespread shift. If the world village has created the consciousness that everyone belongs to an interdependent minority, then this has created a certain pragmatic *Realpolitik*. There's a new, grudging recognition of differences, in the inner cities a

[47] Federico Fellini, *Ginger and Fred*. The dark irony of an old dance couple, who did take-offs of Fred Astaire and Ginger Rogers, returning to a tv celebration to relive their past ersatz creation. The encounter of many such fabrications on a tv show creates the carnival of Post-Modern life, the hilarious and sad juxtapositions of disembodied tastes. (Recorded Releasing)

[48] Gae Aulenti and ACT, Musée d'Orsay, conversion, 1980-6. An inclusive architecture and view of the past and present which accepts contrary values and makes a varied comment on them. Nineteenth-century tastes in art, both academic and Modern, are mirrored by twentieth-century ironies and technology, as well as beautiful lighting and a very rich development of layered space. (C. Jencks)

'live and let live', as long as the jobs don't run out. Also there's a much more cosmopolitan attitude towards the conflict of different world views. The ideology of Modernism was often exclusivist at its core, seeking to draw into one sensibility and view of history the plurality of discontinuous taste cultures. Its characteristic creations were the factory, Sixth Avenue in New York, the Museum of Modern Art, the Ford Motor Company, the straight-line history of Modern Art from Impressionism to Abstract Expressionism, the philosophies of pragmatism and Logical Positivism and above all the emphasis on steady economic growth at all costs. Ultimately, Modernism was the ideology of modernisation, and it lasted as long as that Faustian goal could be seriously pursued by the best minds and those with most power.

But after the 1960s people became aware of the 'limits of growth', of the social upheavals caused by modernisation, and aware that they could only increase as modernisation was exported to the so-called 'Second and Third Worlds'. If it isn't the destruction of the ozone layer, or another set of Chernobyls, it will be the creation of three more megalopolises of thirty million people; if it isn't limited nuclear war between two poor countries, it will be the coercion of their populations into factories to work for the richer ones. The so-called 'First World' has sent its industrialisation packing to Mexico City and South Korea and tried to keep the monopoly of the control technologies, the information industries, to itself. But this is unlikely to last for long since these technologies are radically decentralising in effect and by nature hard to monopolise. The Post-Modern information world will more likely result in a dynamic set of city cultures based all around the globe which will change their positions of strength relatively faster than they did in the Modern era.

Perhaps the ultimate paradox of the Post-Modern situation, the condition built on paradox and irony, is that it can willingly include the Modern and Pre-Modern conditions as essential parts of its existence. It has not taken an aggressive stance with respect to an agricultural civilisation, it has not sought to destroy industrialisation, nor put forward a single totalising ideology. The Post-Modern sensibility thrives on dispositions different from its own and recognises how dull life would be if it all took place in the world village. This enjoyment of difference helps explain why the content of so much Post-Modernism is the past seen with irony or displacement. It's the realisation that we can return to a previous era and technology, at the price of finding it slightly different. The Post-Modern situation allows its sensibility to be a compound of previous ones, a palimpsest, just as the information world itself depends on technologies and energies quite different from its own. The present situation can not only include the previous ones, but benefit by their existence. We now have the luxury of inhabiting successive worlds as we tire of each one's qualities, a luxury previous ages, with their lack of opportunity, did not have. There is no dictatorship of the cognitariat, nor is there an exclusive aristocracy or bourgeoisie but rather the first para-class to have it all ways.

VII The Beginning of the Post-Modern Era

The feeling that we are living through a turning point in history is widespread. But this mood has been pervasive for the last two hundred years, a period of continuous transition. Nevertheless the types of change that affect us seem more radical and thoroughgoing than in previous years, with deep social and political consequences. Perhaps the most momentous shift of some thirty under way is the breakup of the Modernist paradigm of Marxism and centralised economic planning in socialist countries (some of which could be called State Capitalist). If Eastern Europe is turned into a neutral zone (or 'Austrianised'), if Russia and China successfully introduce 'market social-ism' – a hybridisation typical of Post-Modernism – then these changes in economics and ideology of one third of humanity will be the most fundamental shift in our time.

The short-lived student movement in China shows some of the characteristic changes in style and practice. Motivated by a minority appeal for social justice and increased freedom, it was essentially a spontaneous, self-organising event dependent on decentralising technologies such as the fax, two-way radio, motor-bike, TV and telephone. These allowed instant communication locally and globally. Its style and content were quintessentially hybrid, mixing quotes from Mao with phrases taken from the French and American Revolutions and their Bills of Rights. Indeed its symbol, the Goddess of Democracy, was a mixture of French *Liberté* and the American Statue of Liberty, and it was erected across from the large portrait of Mao on the Tiananmen square. The music during the long hours of waiting varied from Chinese singing to broadcasting, on makeshift loudspeakers, the 'Ode to Joy' from Beethoven's *Ninth Symphony* with its message of global brotherhood .

Whenever an international television crew swung its cameras over the crowds, up went the two-finger salute of Winston Churchill. (Did it have some specific Chinese overtone beyond 'V for Victory'?) Headbands had dual-language slogans: 'Glasnost' above its Chinese translation (again so TV could beam the instant message around China and the English-speaking world). When the final debacle came at Tiananmen Square its impact was immediate throughout the globe because of television, and it even had some influence on the vote for democracy that was taking place in Poland at the time.[44] Just after the students were crushed, on June 4, 1989, Solidarity won an extraordinary landslide victory that neither they nor the Polish Communist Party had foreseen: all 161 seats that were open to it in the lower house, the Sejm, and 99 out of a hundred seats in the upper house, the Senate. In twenty-four hours the Dictatorship of the Proletariat had taken a Leninist two-step: one back, one forward. Never had political events in these parts of the world been seen, communicated, analysed and judged so quickly by the globe. And this quick reaction of the information world had a feedback effect on the events themselves – for the most part positive.[45]

[49] Tiananmen Square, June 4, 1989, as seen on French television and by the rest of the world. (C. Jencks)

44 See Timothy Garton Ash, 'Refolution in Hungary and Poland', *New York Review of Books*, August 17, 1989, p 10.

45 It is of course impossible to accurately measure the feedback effect of the information world on events in China and Poland, but effect it undoubtedly had as can be judged by the authorities' attempts to counteract and distort it, especially in China. It appears that the Chinese sought to reassure the international business community and convey a picture of normality and reasonableness in all dealing with foreigners *partly in reaction to* the televised massacre and this may, in turn, have had a restraining effect on their suppression. I think it's more obvious that the instant, widespread knowledge of the vote in Poland (especially in Russia) immediately de-legitimised the Polish Communist Party and led directly to the change in government on August 24th – the election of Tadeusz Mazowiecki etc.

[50] Tiananmen Square, June 4, 1989. (C. Jencks)

But if there really is a shift to 'post-socialism' under way (and the term has been used of Britain since the early eighties) then it, like so many other turns in direction, will take twenty to thirty years to be completed. The previous shift to a new paradigm – that from the Medieval to the Modern – was very uneven and different for each nation, field of work and specialisation. And it took more than a hundred years. This might be the time it takes to shift to a Post-Modern world, except that today because of the information flow all change is much faster. If we date the beginning of Post-Modern movements to 1960, then we might imagine the paradigm as a whole starting to dominate the competing ones – the Traditional and Modern – by the year 2000. But the Modern world view hangs on tenaciously and, as Max Planck said of disputes in theoretical physics, one can never manage to convince one's opponents, only aim to outlive them. Already there has been a strong Modernist backlash against Post-Modernism in architecture, led by the RIBA in Britain, Deconstructionists in America and assorted Neo-Modernists everywhere, and similar reactions can probably be found in all the arts and sciences.

Many physicists still won't accept the fundamental reality of the uncertainty principle, chaos theory and the many manifestations of Post-Modern science. With Einstein, who didn't want to give up the Modern world view of an ordered, deterministic and certain cosmos, they insist that God doesn't play dice with the universe. The prevailing paradigms in the science departments of many universities will favour modified Newtonian mechanics and Darwinian evolution in their highly elaborated 'Neo' forms, and such orthodoxies are bound to last because they still describe, quite adequately, the everyday world. The fact that Post-Newtonian and Post-Darwinian theories, of a higher order, can explain a wider range of phenomena and encompass the former theories, is not regarded as particularly significant.

For analogous reasons we can predict that much of the world will carry on happily for the next twenty years modernising and following the ideology of Modernism. After all much of it, like China, is still rural and not yet industrialised. Post-Modernism is a *stage of growth,* not an anti-Modern reaction, and before one country or people can reach it, the various stages of urbanisation, industrialisation and post-industrialisation have to occur.

However, there are developments that lead one to believe the world might shift to the paradigm by the year 2000: above all the crisis of the ecosphere. If conservative estimates of the greenhouse effect are right, by that time much of the world will be involved in a rearguard action, trying to hold back the unintended consequences of modernisation, engaged in a desperate attempt to slow down – or reverse – the inertia of long-term warming and pollution. It may just be that this common problem, or 'enemy', unites the globe in an ethical battle which some philosophers have called 'the moral equivalent of war'. Conversely some scenarios predict that the greenhouse effect may lead to autocratic repression and war. Either way it will make the world hyperconscious of the limits of modernisation, Modernism and all their cognate practices and ideas. Also it will force a consciousness of what that essential Post-Modern science, ecology, has been saying now for more than thirty

years: all living and non-living things on the globe are interconnected, or capable of being linked. Indeed Modern scientists have granted such points for many years, although the paradigm they have worked with – favouring analysis, reductivism and specialisation – has not followed the implications.

Modern sciences have triumphed through specialising on limited parts of reality: extremely few of them, like ecology and ethology, have been holistic. Modern knowledge has progressed by analysing problems into their parts, dividing to conquer, hence the multiple branching of university departments and investigative disciplines over the last two hundred years. Only a few fields, such as philosophy, theology and sociology have made their purview the whole of knowledge, or the interconnection of disciplines, and on these rare occasions only imperfectly so. Perhaps in the future with the environmental crises and the increasing globalisation of the economy, communications and virtually every specialisation, we will be encouraged – even forced – to emphasise the things which interact, the connections between a growing economy, an ideology of constant change and waste. Those who don't realise the world is a whole are doomed to pollute it.

So one of the key shifts to the Post-Modern world will be a change in epistemology, the understanding of knowledge and how it grows and relates to other assumptions. Not only will it emphasise the continuities of nature, but the time-bound, cultural nature of knowledge. Instead of regarding the world and nature as simply there, working according to immutable laws that are eternally true, the Post-Modern view will emphasise the developmental nature of science – its perspectival distortion in time, space and culture. It will not embrace an absolute relativism and contend that one scientific hypothesis is as good as another, or as Jean-François Lyotard has argued, a complete scepticism and an end to all master narratives and beliefs. Rather, it will support relative absolutism, or fragmental holism, which insists on the developing and jumping nature of scientific growth, and the fact that all propositions of truth are time- and context-sensitive.

If the truths of Post-Modernism are culture-dependent and grow in time, this helps explain the hybrid nature of its philosophy and world view; why it is so continuously mixed, mongrel and dialectically involved with Modernism. Among the thirty or so shifts that have the prefix 'post', look at Post-Fordism. Like all the other 'posties' this concept implicates its forerunner in a complicated way. It doesn't contend that Fordism (the large corporation with central planning and mass-production) is dead, or completely transcended, or unimportant, or no longer powerful. Rather it asserts that a new level of small businesses has grown – fast-changing, creative, and networked by computer and an array of communicational systems – which has a complementary existence to large organisations. Post-Fordist enterprises may have accounted for more than fifty per cent of the new jobs in Italy and the United States during the eighties, and now they exist in a symbiotic relationship to transnationals and big companies, forming an economy that is more flexible and creative than one based simply on the Modernist and Fordist model.[46]

46 The phrase 'Post-Fordist' starts some time in the early 1980s in juxtaposition to the large corporation based on the model of Henry Ford. For a discussion of it within a Post-Modern context see the impressively argued book *The Condition of Post-Modernity*, David Harvey, Blackwells, Oxford, 1989. For a critical discussion of where new jobs came from – and their percentages – see 'The Disciples of David Birch', John Chase, *Inc.*, January, 1989, pp 39-45. Companies with fewer than 100 employees, from 1969-1986, have in the USA created an average of 65% of the new jobs – according to the most reliable statistics. But these statistics can be questioned.

[51] 75 State Street. An internal curving arcade, on a Y-plan, that recalls the exterior ornament, pulls the adjacent streets through the building and gives them a warm, masonry background. (C. Jencks)

[52] Graham Gund and Adrian Smith (SOM), 75 State Street, Boston, 1987-9. A 31-storey tower with gold-leaf v-forms and beige and red granite skin helps complete the Fanueil Hall Marketplace area. The complex picks up the surrounding buildings with a six-storey base, set-backs, stepped corners and a new/old vocabulary. Fanueil Hall Marketplace combines elements of Post-Modern urban theory – mixed-uses, mixed-ages, public realm supported by street theatre – with a commercial and social formula partly evident at Disneyland. The developer James Rouse has often modified this formula to bring in small-scale enterprises and employment for blacks and other minorities. Here it has produced what is now, perhaps, the most urbane place in recent American design. (Steve Rosenthal)

Post-Feminism, in a similar manner, does not refute, deny or seek to overturn its forerunner. Rather it recognises the ideology and gains of feminism and then asks for the recognition that where women do differ from men – for instance in the desire for motherhood – society and the business world accommodate this difference positively. Post-Feminism, like the other posts, is not reactionary or Pre-Modern, but hybrid. It selectively merges the distant and recent past to come up with a different way forward.

Such hybridisation, or dualism, or symbiosis, or ambiguity, or complexity may be taken as the stylistic hallmark of the new paradigm. But it also explains why Modernists have found this style too familiar and have been over-zealous in condemning it as pastiche. Architects who have been nurtured on a diet of Futurism, engineering and the pleasures of juxtaposition, abstraction and surrealism are too quick to confuse quotation with revivalism and memory with accommodation. Similar habits of thought occur in other fields. The Modernist sensibility, forged in a series of disputes with the academic, the clichéd and commercial – the *pompiers* and reactionaries of the nineteenth century – is determined to cast opponents in this guise. Oh for an ancient war! Every generation longs to savour victory over a perpetual Ecole des Beaux-Arts – even if it doesn't exist.

Like Communists seeing a bourgeois 'counter-revolution' behind every demand for freedom, Modernists – in all their 'Late' and 'Neo' phases – find a 'Disneyland' behind every attempt at contextual building. Of course there can be pastiche, whimsy, ornament and a commercial formula behind much successful Post-Modern development today, but these aspects do not summarise or explain its value, nor even distinguish it from successful Late-Modern development. One has to analyse the particular mixture of traditions,

[53] Kisho Kurokawa, Museum of Contemporary Art, Hiroshima, 1986-9. Understated references are made in this museum to bind the past, present and future into an ambiguous, seamless web. Edo storehouses and castles are dimly recalled in the forms and a white Modernism and silver futurism in the materials. (C. Jencks)

[54] Kisho Kurokawa, Museum of Contemporary Art, Hiroshima, axonometric. The sliced rotunda is oriented to the centre of the city, where the A-bomb was dropped. The pitched roof forms, in aluminium, recall Edo storehouses and surmount very appropriate windowless rooms for the art.

[55] Kisho Kurokawa, Museum of Contemporary Art, Hiroshima. The central arrival point in shining metal alludes with considerable circumspection to an Edo storehouse, Western rotunda and perhaps even the flash of the A-bomb. (C. Jencks)

the imaginative transformation of ornament and the exact social implications to determine whether the development is of value, and for this judgement the fact of quotation or reminiscence is of marginal importance.

By contrast there is some Post-Modern architecture, such as that of Kisho Kurokawa, which is so abstract and ambiguous with its references to the past that one may overlook their existence altogether and only sense their suppressed presence. The wide spectrum of approaches within the movement extends from the fairly explicit ironies of Robert Venturi to the sophisticated juxtapositions of James Stirling to the understated abstractions of Kurokawa. This heterogeneity should no more be summarised as pastiche than all of Modernism as brutalist.

After all, both movements and paradigms are multiple and time-dependent. There is no single *Zeitgeist* of Post-Modernism any more than there is a unitary Gothic or Baroque 'spirit of the age'. The 'world spirit', that phantom of Modernists such as Marx and Le Corbusier, has been transcended, at least conceptually if not politically, by notions of a 'world view', a *Weltanschauung,* a paradigm, an *épistémè*, a climate of opinion, a set of immanent traditions and so forth. Each one of these concepts points to a slightly different constellation of ideas and practices within culture, but they all allow the crucial aspect of choice and judgement. If one thing determines the course of the world it is *culture* – which is to say it is undetermined.

This point is now being more deeply understood because of everincreasing developments in biology, evolution, chemistry and physics, discoveries and theories which stress the spontaneous self-organisation found throughout the material and natural universe.

Post-Modernism, in all the fields and nations, is itself an example of such sudden self-determinism and it has arisen, quite independently and at various dates in disciplines as unrelated as history (1947), dance (1975), philosophy (1979) and geography (1982).[47] Why have all of these fields latched on to the term with its coherently ambiguous meanings? What ominous and reverberant messages are latent within the phrase, waiting to reanimate it in each new context?

First of all to be 'post' means to be 'beyond', to be 'more modern than Modern', which is why Modernists feared and were provoked by the phrase. This historicist overtone may be denied by Post-Modernists, especially when they criticise the institutionalisation of the avant-garde; but it certainly made the Shock of the New feel like the Yawn of the Old. How else explain the Modernists' continued paranoid attacks at the RIBA.[48] Secondly the term has opposite overtones suggesting 'anti-Modernism' to some Traditionalists who see it as a possible ally; or 'the continuation of Modernism in a new guise' to other Traditionalists who see it as a threat. Thirdly it has hallucinatory overtones suggesting an impossibility – the 'post-present' – as if it were suspended beyond time in some paradoxical Wonderland or hyperspace of advanced physics, a kind of chronological equivalent of anti-matter. Finally, to many of its adherents and me, it suggests the possibilities of hybridisation, of being partly Modern and partly something else, or a critical and selective continuation of Modernism and its transcendence. No doubt these suggestive, but somewhat contradictory, meanings explain its polemical force and the reason for its widespread usage – a popularity and acceptance within critical discourse that has surprised its critics as much as its defenders. These varying overtones also explain the ambiguity and confusion of the term, a riotous heterogeneity that hasn't always been negative – because of its creative ambiguity. The muddle in the public's mind and the inflation of the term are, however, regrettable side-effects of this plurivalence.

But of course many events on which the term has been pinned took place quite independent of any labelling and only rarely has an event actually been created as 'Post-Modern'. The Post-Industrial society and Post-Fordism as much as Post-Marxism are not Happenings organised by impresarios for some cosmic art market. And thus the general meaning of the term refers not to its emotive overtones and suppressed historicism, but to the collection of specific traditions, beliefs and technologies seen as a whole. Needless to say, this whole is full of holes. It has discontinuities, contradictions and unfinished parts, as does anyone's personality. But with all its blemishes, fractures and missing elements, it still hangs loosely together as a partial cultural paradigm to compete with those fragments of traditional and modern culture that still exist and have vitality. Whether individual works produced in this new paradigm are of value is partly a matter of how well they measure up to the traditional canons of judgement – imaginative transformation, cultural relevance, depth of feeling, skill – and partly a question of how they deal with our curious hybrid moment which has its own potential.

[56] Lawrence Scarpa, Gwynn Pugh, Jim Dine, Michael Orth, *Evolutionary Chair*, welded metal swivel seat, stainless steel mesh, concrete base and wooden joinery, 1989. At once 'beyond' the Modern chair and 'pre'-Modern, this seat as sculpture and function summarises the evolution of sitting on rocks and crafted objects to the latest speculations on moving, high-tech chairs. A hybrid contrast of periods, materials and ontological categories – but is it a chair? (Photo courtesy of the architects)

47 These somewhat arbitrary dates are those when a major publication in the respective fields first used the term post-modern in a conceptual and historical sense.

48 By now these are ritualised, as was evident in Max Hutchinson's inaugural address as President of the RIBA, July 1989.

[57] Anselm Kiefer, *The High Priestess – The Land of Two Rivers*, 200 lead books in two steel bookcases, 14 feet high, 26 feet long, 3 feet deep and weighing 30 tonnes, 1985-9. The role of books as a by-product of the mind – dead, catalogued thoughts waiting in monumental solemnity to be revived after some nuclear meltdown – is suggested by these lead tomes resembling parchment. The apocalyptic feeling is reinforced by the photographic images inside each huge book, often of ruined or decaying cities seen from afar. A quotation from Borges' *The Library of Babel* summarises the mood: 'The human species – the unique species – is about to be extinguished, and the Library will endure . . .' The threat of eco-disaster taken up in the staining and corrosion is however balanced by *The Land of Two Rivers* – the 'Tigris' and 'Euphrates' represented as two sides of the open steel bookcases and given handwritten labels, as often in Kiefer's work. He, the minimalist Wagner of Post-Modernism, uses natural and artificial materials to give a presence to grand themes whose struggle is more often hinted at than faced. (Courtesy of the Anthony d'Offay Gallery, London)